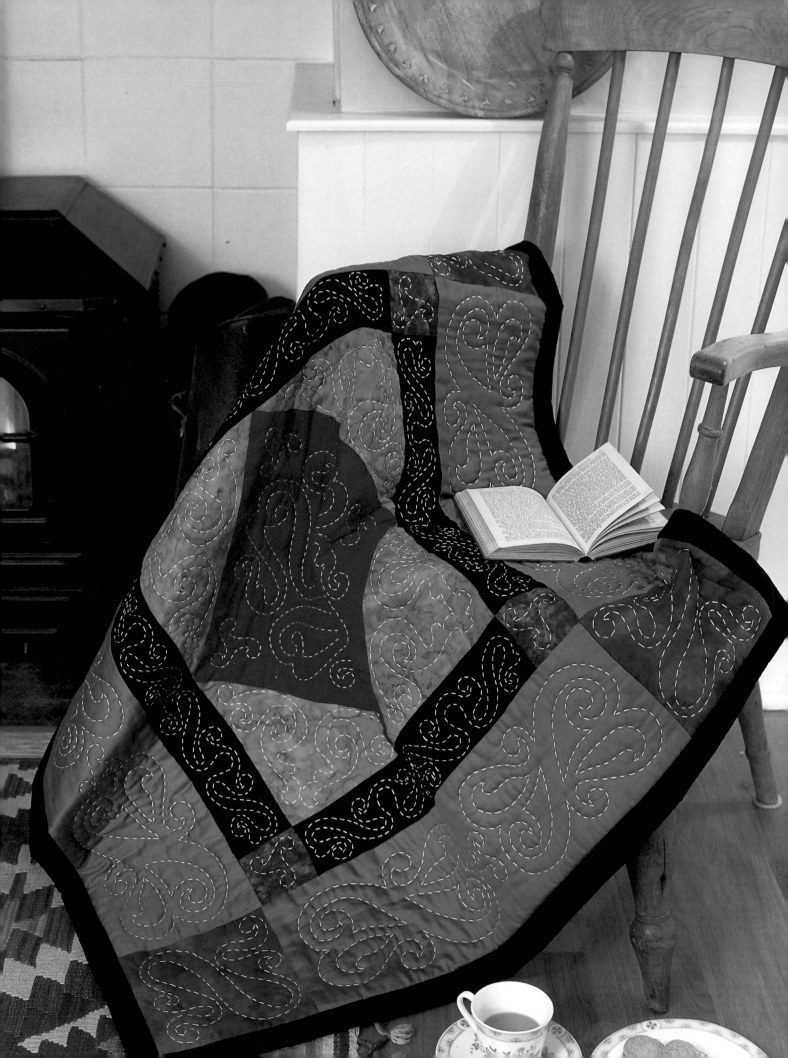

MORE
CELTIC QUILTING

OVER 25 NEW PROJECTS FOR PATCHWORK, QUILTING, AND APPLIQUÉ

Gail Lawther

kp
krause

For Chris,
my travelling companion

Many thanks to Jennie Ring for her excellent stitching on the dragon bolster, knotwork cushions, glasses case and lavender bags.

Copyright © Gail Lawther, 2004

Gail Lawther has asserted her right to be identified as author of this work in accordance with the Copyright, Designs and Patents Act, 1988.

First published in the UK in 2004 by
David & Charles
Brunel House Newton Abbot Devon

A catalogue record for this book is available from the British Library.

ISBN 0 7153 1692 3

Paperback edition published in North America in 2004 by Krause Publications, an F&W Publications Company
700 East State Street, Iola, WI 54990
715-445-2214/888-457-2873
www.krause.com

A catalog record for this book is available from the Library of Congress: 2003115538

ISBN 0-87349-862-3

Printed in China by Hong Kong Graphics & Printing Ltd.

Executive commissioning editor Cheryl Brown
Desk editor Ame Verso
Executive art editor Ali Myer
Art editor Prudence Rogers
Project editor Lin Clements
Photography Kim Sayer and Karl Adamson

CONTENTS

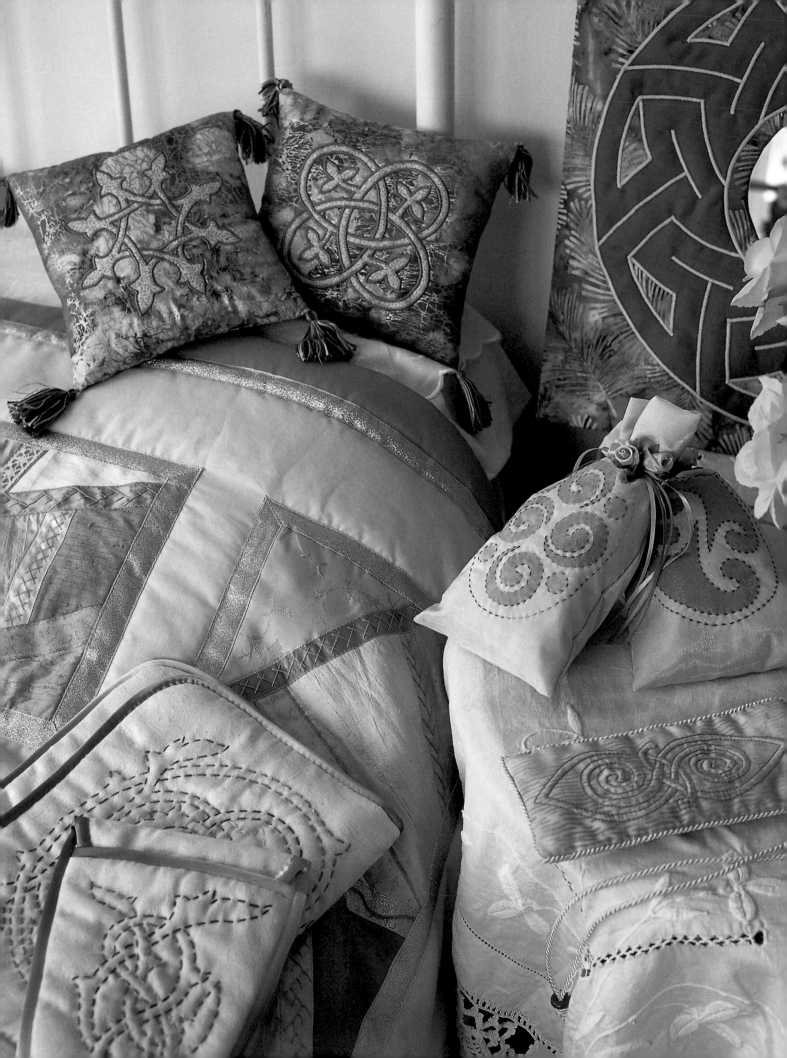

INTRODUCTION

Exuberant lines, characterful animals, intriguing geometry, breathtaking detail and imaginative colour schemes – the beauty of Celtic art is as awe-inspiring today as it must have been when it was first created centuries ago. I've been interested in Celtic designs for as long as I can remember and have discovered that many aspects of this art lend themselves superbly to all sorts of quilting. The designs in my first book, *Celtic Quilting*, proved so popular that I felt it was now time to bring out a new collection! So I'm delighted to present *More Celtic Quilting*.

Since the first book, many new and exciting fabrics have come on to the market, complemented by a still wider variety of wonderful threads, beads, trimmings, waddings (battings), and even new patchwork and quilting techniques.

The barriers between quilting, embroidery and decorative textile techniques, such as fabric painting, have broken down and many modern stitchers are combining techniques in their work, as I have tried to do in this book.

Celtic art is a rich and continual source of inspiration. If you're interested in doing your own research visit a good library or search on the Internet and you'll find all kinds of reproductions of original art – from facsimiles of the great illuminated manuscripts through to woodwork and stone-carving in the Celtic tradition. For all the projects and ideas in *More Celtic Quilting* I've gone back to original ancient sources (or at least reproductions of them!) and created new designs from their inspiration – doing my part, I hope, to keep the Celtic tradition alive in the modern world.

Using This Book

In the first few pages of the book I've provided a simple introduction to the equipment, fabrics, threads and other materials that are useful for quilting, with a few tips and guidelines that will be particularly useful to beginners.

The project part of the book is divided into four sections, each one covering a different aspect of Celtic art: knotwork; spirals; fret, key and carpet-page designs and plant and animal designs. Each section contains four projects: a simple one, two at medium level and one more complex. Some of the projects contain several designs, so there is a wealth of different patterns and ideas to choose from, providing inspiration for any level of stitching experience.

At the beginning of every project you'll find an easiness rating, plus a guide to the techniques you'll need to complete that particular piece, which should help you decide which projects suit you best.

Within each project I also suggest ideas for varying or adapting it in different ways, so you don't have to copy what I've done but can make each piece of stitching uniquely yours. You'll also find a useful library of additional patterns beginning on page 110.

The last section of the book describes the general techniques you will find useful if you're a beginner, or to refresh your memory if you've been stitching for a while. You'll find topics such as enlarging patterns, marking and transferring designs, preparing a quilt 'sandwich', piecing and quilting by hand or machine, and also some useful finishing techniques.

Variations on a Celtic Theme

Just to whet your appetite and to show you some of the many ways you can vary and adapt even the simplest Celtic design, I've stitched a series of samples using the same basic knot design (see diagram on page 111).

A A subtle version of the knot worked in wholecloth quilting in a toning thread.

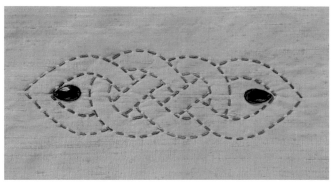

B Sashiko stitching (see page 104) in a variegated thread, embellished with fake jewels.

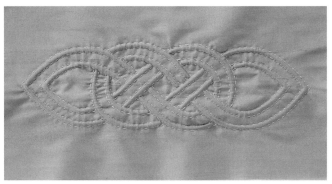

C Italian (corded) quilting (see page 108) worked on the outlines of the design.

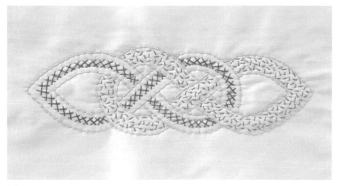

D The knot worked with backstitch outlines and filled in with hand embroidery.

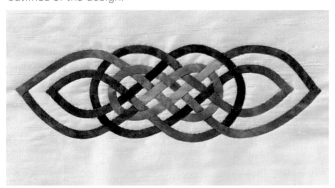

E The design created in fusible bias binding (see page 32), interwoven as separate knots.

F An extra central line added, worked in whipped running stitch in variegated thread.

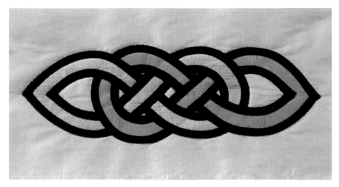

G The knot created in stained-glass patchwork (see page 107).

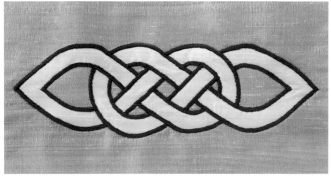

H The design appliquéd in place with lines of machine satin stitch (see page 105).

MATERIALS AND EQUIPMENT

This short section provides you with a useful checklist of equipment, fabrics, waddings (battings) and threads, plus some handy tips.

Basic Sewing Kit

If you are a stitcher, you probably already have most of the things that you need for quilting in your sewing basket. If you're a total beginner, invest in a good set of basics and add to them as you develop your interest in different types of quilting.

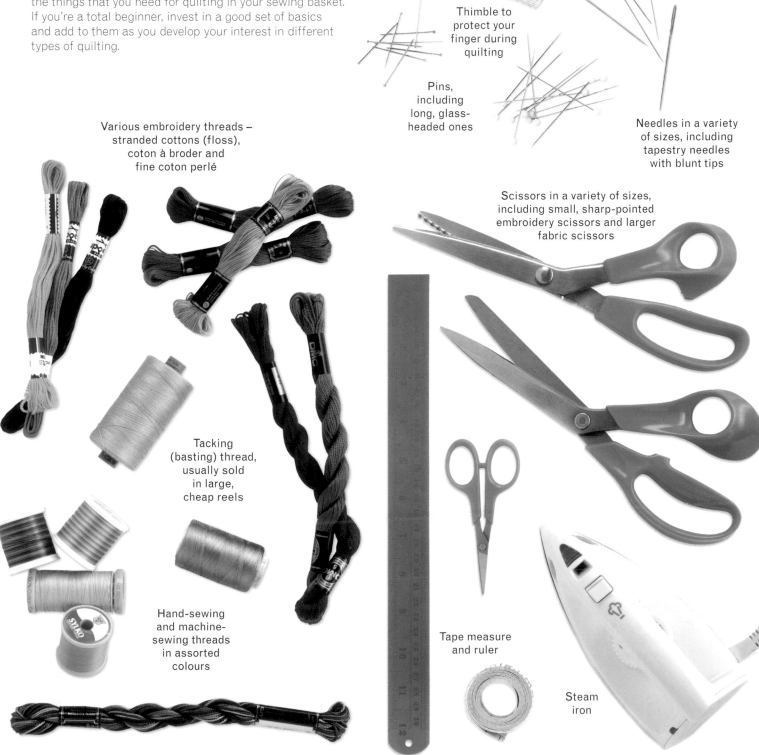

Thimble to protect your finger during quilting

Pins, including long, glass-headed ones

Needles in a variety of sizes, including tapestry needles with blunt tips

Various embroidery threads – stranded cottons (floss), coton à broder and fine coton perlé

Scissors in a variety of sizes, including small, sharp-pointed embroidery scissors and larger fabric scissors

Tacking (basting) thread, usually sold in large, cheap reels

Hand-sewing and machine-sewing threads in assorted colours

Tape measure and ruler

Steam iron

Useful Extras

There are countless gadgets made especially for quilters. Most of them are not essential but the following items are invaluable.

- Rotary cutter, self-healing cutting board and basic, long quilter's rule.
- Quilting thread, which is thicker and stronger than ordinary sewing thread.
- Quilting frame, either a hand-held one (like a large embroidery hoop), a plastic clip-on frame, or a floor-standing frame.
- Template plastic, sheets of translucent plastic useful for making templates and transferring designs.
- Teflon sheet for protecting some fabrics during ironing.

Optional Extras

The following items are useful if you have them, but if you're just starting out don't bother to buy them especially. Particular projects will specify other materials needed, such as beads, bias binding, bonding web, interfacing and tassels.

- Bodkin or a large, blunt needle useful for threading the channels in Italian (corded) quilting.
- Pinking shears.
- Safety pins.
- Flat-headed or 'flower' pins, which are less likely to get caught up in the folds of fabric and the sewing machine foot as you stitch.
- Tack gun (see page 102).
- Extra-fine pins, useful for fine fabrics such as silks and metallics.
- Appliqué scissors.
- Long ruler or yardstick.
- Graph paper or template paper (pads of paper marked with regular designs in various patterns).
- Protractor, set square, set of compasses, circle templates in assorted sizes.
- Quilter's rules and templates in various sizes and shapes.
- Soft thimble for the underneath finger when quilting.
- Walking foot for your sewing machine.
- Mini-iron, which has a tiny sole-plate useful for pressing seams and bindings.

Non-sewing Supplies

You will need a good supply of basic drawing materials for enlarging, tracing, copying and transferring designs.

Paper scissors

Pencil crayons for colouring in designs and marking fabric

Marking pens, pencils, chalk liners and so on for marking designs (see page 100)

Pencils, good pencil sharpener and eraser

Fabrics

Using only 100% cotton fabric for quilts is a good general principle for items such as bed quilts and cot quilts that are going to be washed numerous times. For other items, almost anything goes – especially if you're creating wall hangings or art quilts. Here are a few general pointers on fabric:

- Most fabrics these days don't shrink or run when washed but if you're not sure, wash the fabric by hand or machine before you cut and piece it. If you do like to pre-wash, you can restore that 'just-bought' feel by spraying the dry fabric with spray starch and pressing it.
- Both print and plain (solid) fabrics work well in patchwork but if you're a beginner it might be best to avoid stripes or checks for a while as these are a little trickier to work with.
- Silk is wonderful for patchwork and quilting but avoid very fine silks as they are difficult to handle. Dupion works well and looks beautiful when quilted but it does fray badly, so add extra to seam allowances when cutting out patches. If silk is slightly floppy and tends to distort as you work on it, spray with spray starch then iron it dry, or stabilize it with a backing of lightweight iron-on interfacing.
- Velvets look sumptuous but can also tend to fray badly; add extra seam allowances if you're using velvet for piecing. To press velvet without crushing the pile (and fabrics such as corduroy and fur), lay the fabric face down on a soft towel and steam press gently from the back.
- Metallics add wonderful sparkle to your work. Some of the older metallic fabrics such as lamés fray badly, but modern ones are often bonded and behave almost as well as cottons. Be careful when pinning metallics as pins can leave marks, and also when pressing – a teflon sheet can ensure that fabrics don't stick to the iron.
- Foundation fabrics are sometimes used for techniques such as crazy patchwork and stained-glass patchwork. Use something cheap, relatively lightweight but firm – sheeting works well and also calico (muslin). For backing

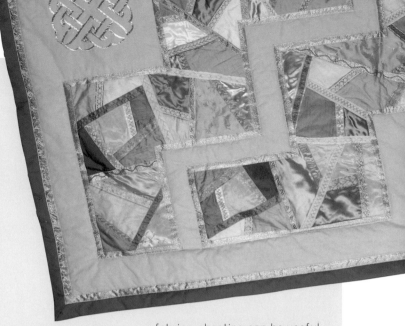

fabrics, sheeting can be useful as it comes in generous widths, and most quilt shops sell backing fabrics cheaper than patchwork fabrics.

- Recycling is how patchwork began and it's still possible to use bits of old garments, curtains and so on in your work. Cut out any stained, worn or faded areas and discard them, then remove any seams, hems and trimmings such as zips, buttons and beads. Wash cotton fabric in warm soapy water and spray it with spray starch as you iron it to make it easier to handle. Remember that if the fabric has been worn hard in its previous incarnation, it may not wear as well as new fabric in your patchwork project.
- Colour is a very personal thing and the colours you choose for particular projects will depend on your own preferences and the project you're working on. Don't feel that you have to stick to the colours I've used for the projects; try your own variations or pick colours that tone with your décor. Go with your instincts – if you like it, it's almost certainly fine!

Waddings (battings)

Wadding, or batting, provides the 'squishy' layer in quilting. The types available can be overwhelming but if you're a beginner, start with a simple, slightly compressed 2oz polyester as this will give good results on virtually any project, whether you're quilting by hand or machine. As you quilt more, you can experiment with other waddings as your confidence grows.

- Loft is the amount of squashiness in a wadding (batting). A low-loft type (such as the slightly compressed one I have suggested above) is easier to handle than a more bouncy one.
- If you're making something that will need to be laundered, check that the wadding is washable (most of the polyester ones are), or pre-wash it if necessary. Some waddings are guaranteed to shrink so that you can make up a quilt, wash it, and instantly achieve the slightly wrinkled 'antique' look of old bed quilts!
- If you're making a quilted garment, use a soft, lightweight, thin wadding so you don't feel like an armoured tank when

wearing it. Try silk wadding, or one of the thin woollen ones, or use a layer of lightweight wool fabric as your middle layer.

- If possible, avoid joining pieces of wadding as the join line can show through your finished work. If making a bed quilt, you can buy ready-cut wadding pieces, right up to king-size proportions. If you find you do need to join pieces, lay them side by side so the edges butt up and use a loose herringbone stitch across the join to avoid pulling the edges up and creating wrinkles. Don't overlap the pieces as the bulge will probably show on your finished quilt.

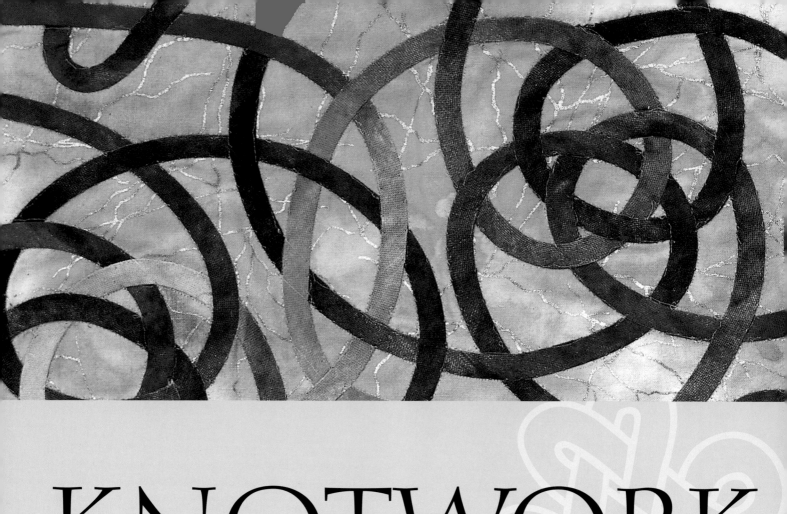

KNOTWORK

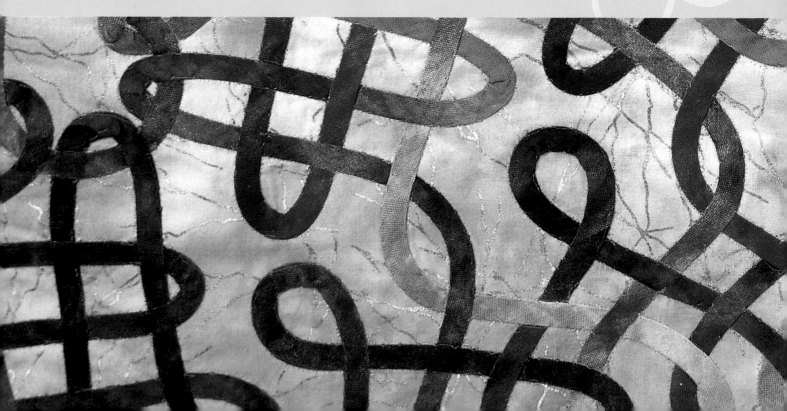

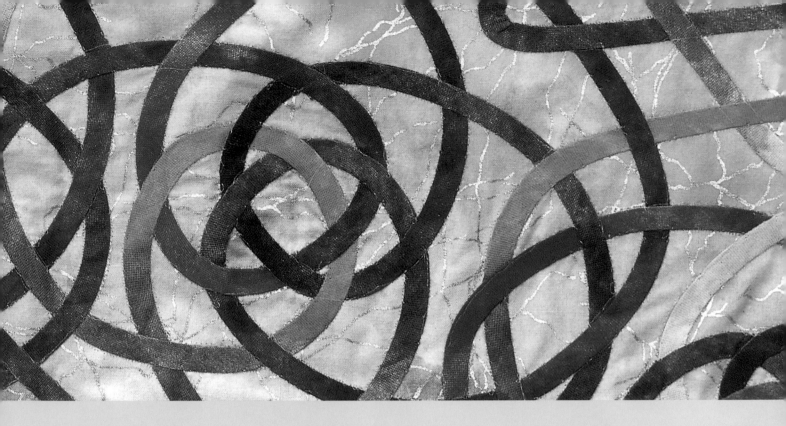

sk anyone to describe Celtic designs and the patterns they'll think of first and foremost are the elaborate knots. These flowing designs seem to hold an eternal fascination for people – and they're also the most adaptable of Celtic patterns as you can design a knot to fit into any shape you care to imagine. On the following pages you'll find a selection of designs based on Celtic knots, ranging from the very simple to the complex – with plenty in between. I've used a variety of different techniques to interpret and embellish the knots, and I'm sure that you'll come up with many more ideas of your own.

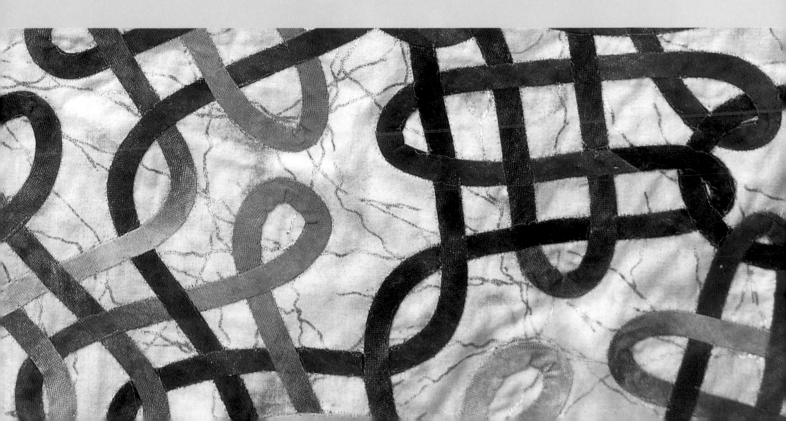

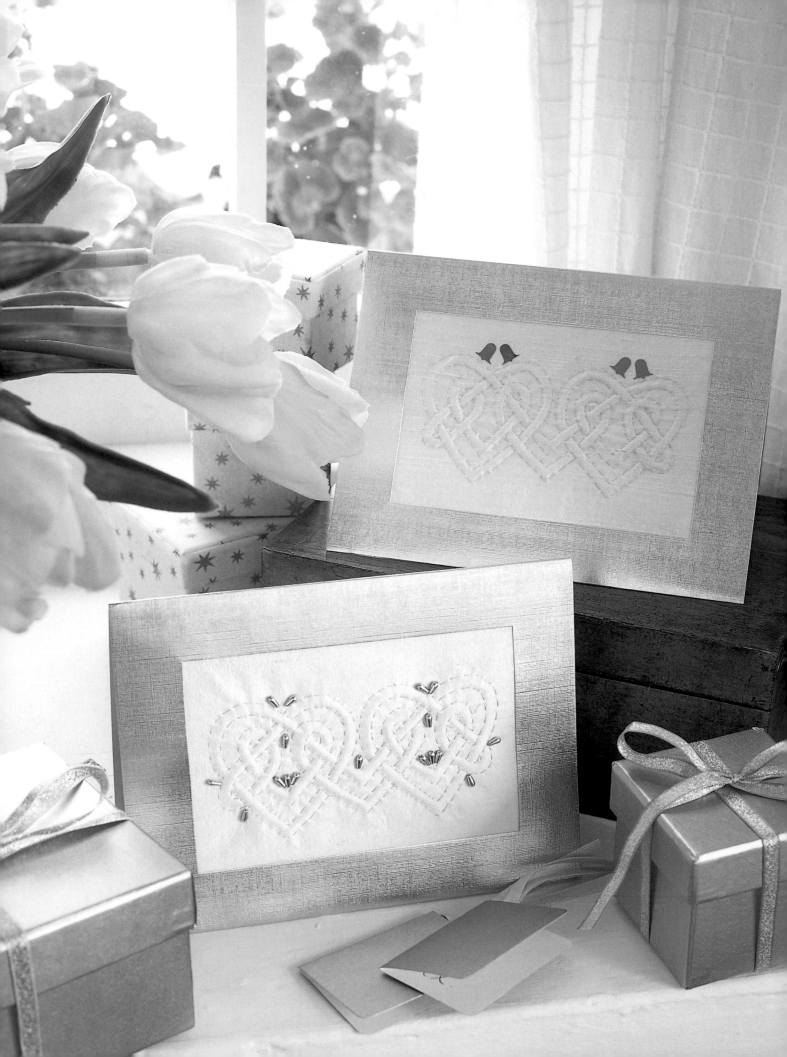

ANNIVERSARY CARDS

Mark that special day with a card worked in the appropriate colours. I've created cards for a silver, gold, ruby and diamond wedding but you could easily adapt the design for an emerald or pearl anniversary. The design is a simple knot made from two hearts; the stitched lines create channels, which are then threaded with wool (yarn) to produce the padded effect. Each card is made up in the same way; I've used the ruby wedding card to show you how the design comes together.

Easiness Rating
Easy ☆
The design is small, the technique very straightforward

Techniques Used
Running stitch
Italian (corded) quilting
Simple embellishment
Making up a card

Finished Size of Design
12.7 x 6.3cm (5 x 2$\frac{1}{2}$ in)

M A T E R I A L S

For all cards:
- Lightweight iron-on interfacing roughly 22 x 16cm (8$\frac{1}{2}$ x 6$\frac{1}{2}$in)
- Firm cotton fabric roughly 22 x 16cm (8$\frac{1}{2}$ x 6$\frac{1}{2}$in)
- Sewing needle and bodkin
- Small amount of tapestry wool (yarn) in white or cream
- Glue stick
- Suitable beads, sequins, charms and buttons for embellishment

For silver wedding card:
- White silk dupion roughly 22 x 16cm (8$\frac{1}{2}$ x 6$\frac{1}{2}$in)
- Matt silver card blank with rectangular aperture 14.5 x 9.5cm (5$\frac{3}{4}$ x 3$\frac{3}{4}$in)
- Silver embroidery thread
- Grey pencil crayon

For golden wedding card:
- Ivory or cream silk dupion roughly 22 x 16cm (8$\frac{1}{2}$ x 6$\frac{1}{2}$in)
- Matt gold card blank with rectangular aperture 14.5 x 9.5cm (5$\frac{3}{4}$ x 3$\frac{3}{4}$in)
- Gold embroidery thread
- Yellow pencil crayon

For ruby wedding card:
- Pink silk dupion roughly 22 x 16cm (8$\frac{1}{2}$ x 6$\frac{1}{2}$in)
- Pink card blank with rectangular aperture 14.5 x 9.5cm (5$\frac{3}{4}$ x 3$\frac{3}{4}$in)
- Red embroidery or sewing thread (I used a single strand of scarlet Marlitt viscose)
- Mid pink pencil crayon

For diamond wedding card:
- Pale aqua silk dupion roughly 22 x 16cm (8$\frac{1}{2}$ x 6$\frac{1}{2}$in)
- Silver or pale green card blank with rectangular aperture 14.5 x 9.5cm (5$\frac{3}{4}$ x 3$\frac{3}{4}$in)
- Green/blue metallic embroidery thread
- Aqua pencil crayon

Producing the Design

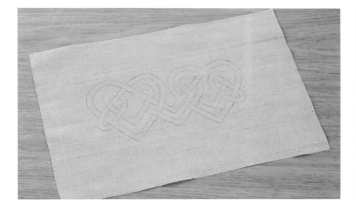

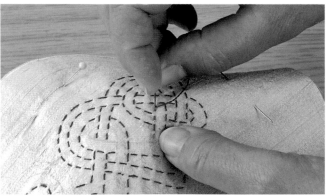

1 Press the silk fabric and lay it over the design template (Fig 1 below), right side up, so there is a roughly even border of fabric all the way around the design. Use the sharp pencil crayon to trace all the lines of the design on to the silk.

3 Lay the silk right side up on top of the cotton fabric and pin or tack (baste) the two layers together around the design. Using your chosen decorative thread, work a line of even running stitches (see page 101) around all the marked lines of the design.

2 Lay the silk face down on an ironing board and use an iron to fuse the interfacing on to the wrong side of the silk. This stabilizes the fairly sheer silk fabric and helps to prevent it from distorting when you thread the channels later.

HANDY HINT

If the fabric needs pressing once you've finished the threading, lay it face down on a soft towel and press from the back. This way, you'll be able to press the fabric without flattening the design.

Fig 1
Design template
for card knot – full size

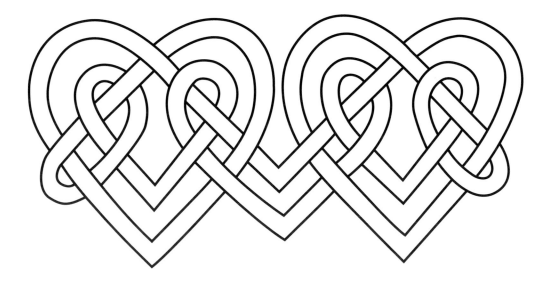

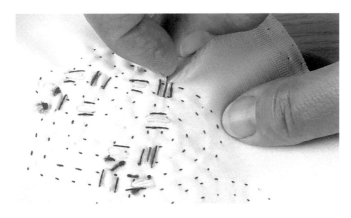

4 Once all the lines are stitched, follow the instructions on page 108 to thread the channels with a single strand of tapestry wool (yarn). Use a bodkin for the threading as the blunt tip makes it easier to thread the channels without piercing the front of the design.

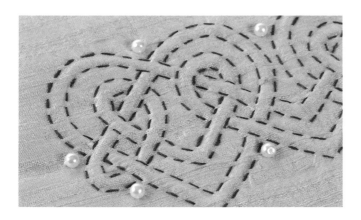

5 Add any embellishments to complete the design, using either matching sewing thread or glue.

Variation

This knot design would work well for a wedding or engagement card, or even as a valentine.

Making Up a Card

1 Trim the fabric down to just inside the size of your folded card blank, making sure the design is centred in the fabric patch. Open the card blank, lay it face down on a flat surface and spread glue all round the edges of the aperture in the central panel.

2 Lay the stitched design face down in the aperture; check from the front that the design is the right way up and centred, then press it down on to the glued area to secure it.

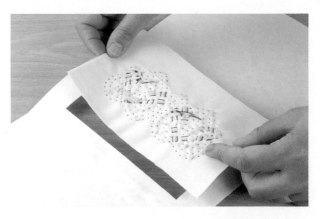

3 Spread glue across the inside of the bottom panel of the card blank, then fold the panel in place over the back of the design to complete your card.

EVENING BAG

A little clutch purse like this is just the thing to hold a few precious bits and pieces during an evening out. You could even make one to match a favourite dress. The quarter-circle shape looks dramatic but is easy to make, and the effect of the knot design is created by a clever use of machine embroidery. For extra opulence scatter a few gold beads around the design.

Easiness Rating
Straightforward ☆☆
If you're confident with simple machine satin stitch

Techniques Used
Machine appliqué
Machine stitching
Simple embellishment
Working with bonding web

Finished Size of Bag
20cm (8in) wide

M A T E R I A L S

- Printed background fabric 45cm (18in) square
- Contrasting silk dupion 45cm (18in) square
- Compressed wadding (batting) 45cm (18in) square
- Reel of gold machine-embroidery thread
 (I used Madeira Gold 4)
- Bonding web 20cm (8in) square
- Yellow pencil crayon or chalk marker
- Sewing thread to match print fabric
- A few gold beads for embellishment

Producing the Design

1 Fold the square of printed fabric into quarters and press the folds. Measuring out from the centre, use a chalk marker or pencil crayon to mark 23cm (9in) lengths along the folds and at various points in a quarter-circle across the square (Fig 1). Join the points to create a smooth curve (Fig 2), and then use large, sharp scissors to cut along the curve (Fig 3).

Fig 1

Fig 2

Fig 3

2 Open out the circle of fabric and cut out one quarter of the circle, leaving a 1.5cm (½in) seam allowance (Fig 4). Now use this shape as a template to cut identical shapes from the contrast fabric and from the wadding (batting). Trim 1.5cm (½in) off all the edges of the wadding shape.

seam allowance added

Fig 4

fold

right side

fold

3 Lay the bonding web, paper side up, over the design template (Fig 5 on page 19) and pin in position. Use a pencil to trace all the solid lines (not the dotted ones) on to the paper. Remove the pins.

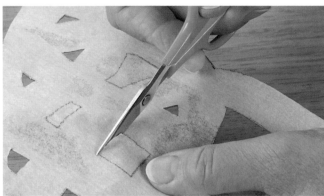

4 Lay the bonding web design, web (rough) side down, on the wrong side of the spare quarter of contrast fabric and fuse into place with an iron. Use small, sharp-pointed scissors to cut out the shape.

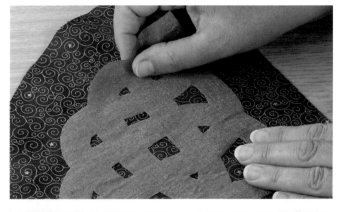

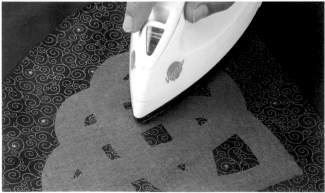

5 Peel the paper off the back of the fabric shape. Lay the print fabric shape on an ironing board, right side

up, and position the contrast fabric knot (bonding web side down) on the top right quarter. Fuse into place with an iron.

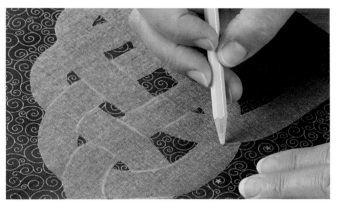

6 Use the yellow crayon or chalk marker to draw in the dotted lines as shown on the template opposite; these create the 'overs' and 'unders' of the knot design.

7 Position the wadding (batting) on the back of the print fabric with an even border of fabric all around and tack (baste) the two layers together. Set your sewing machine to a medium-width satin stitch (3–3.5) and stitch along the outsides of the knot, carrying the stitching across the fabric along the marked lines where appropriate, to create the illusion of an overlapping knot.

HANDY HINT

If you find that your satin stitch tends to create undulations in the fabric, use a square of foundation paper (for instance, Stitch 'n' Tear or white cartridge paper) under the stitching and tear it away once the stitching is complete.

Making Up the Bag

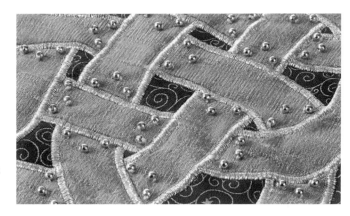

8 Lay the print fabric and the contrast shape right sides together and stitch a 1.5cm (½in) seam around the edges, leaving about 15cm (6in) open on part of the outside curve for turning (Fig 6).

9 Clip the corners and turn out the design then slipstitch the opening closed with matching thread (Fig 7). Fold one quarter of the shape over the middle quarter, leaving the decorated quarter free, and slipstitch the edges together along the curve to create the bag shape (Fig 8).

10 Using matching sewing thread, add a few gold beads to the knot to embellish it if you wish.

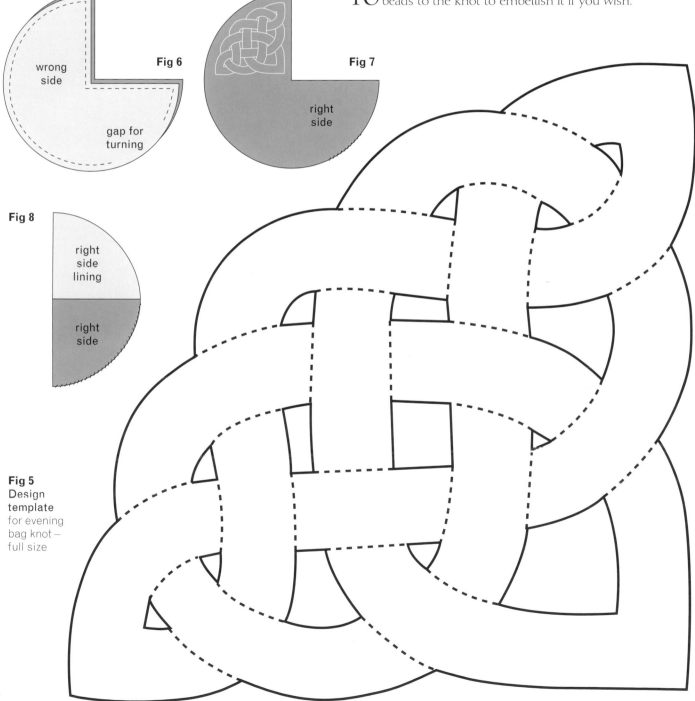

Fig 6

wrong side

gap for turning

Fig 7

right side

Fig 8

right side lining

right side

Fig 5
Design template for evening bag knot – full size

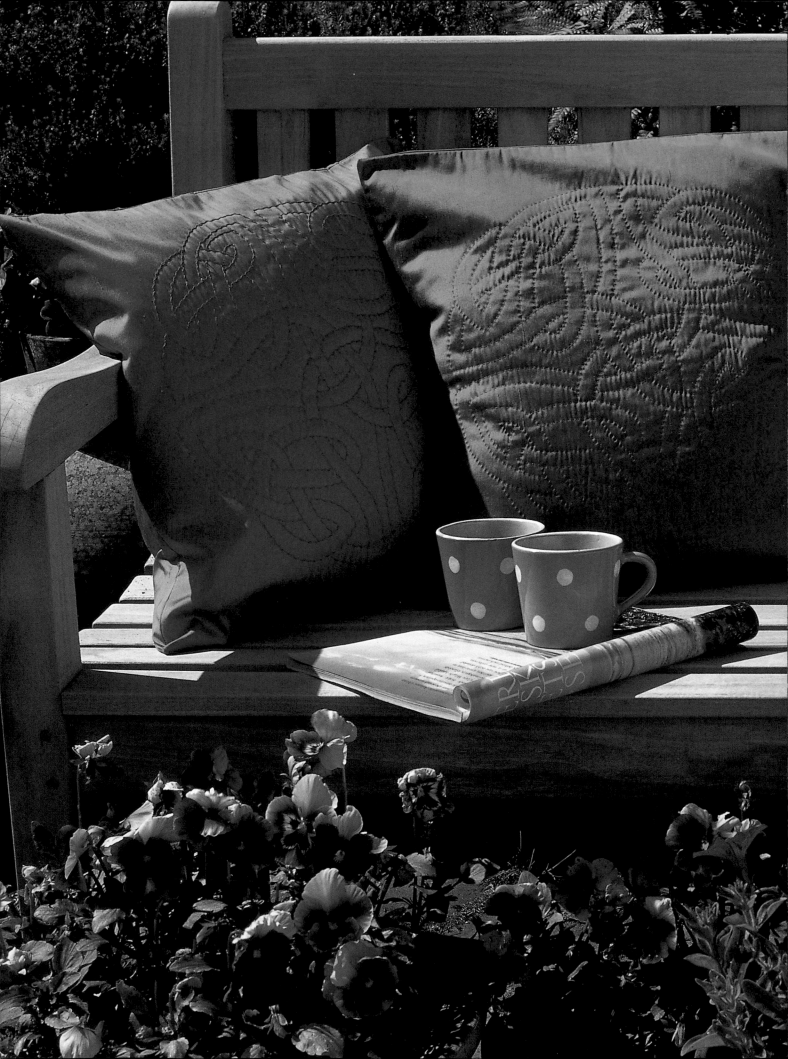

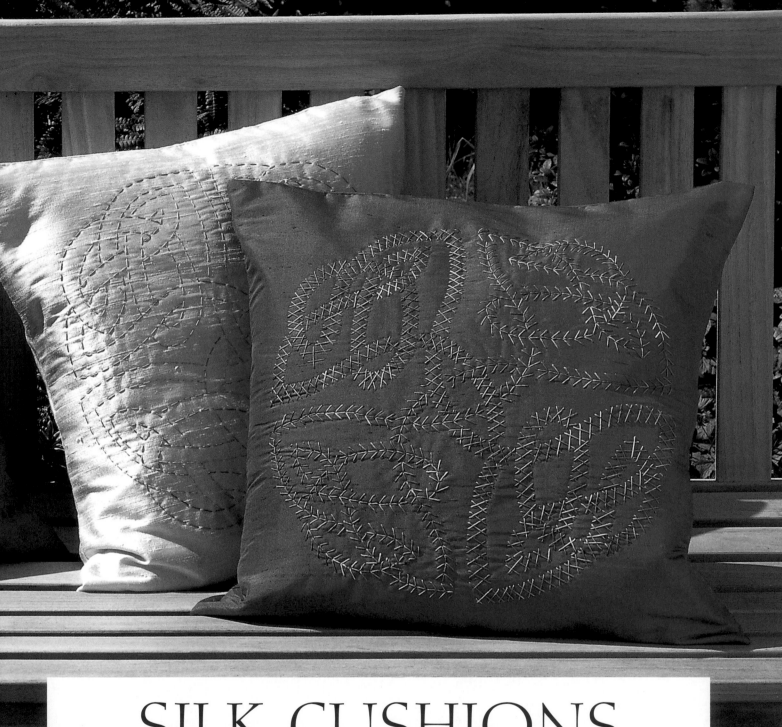

SILK CUSHIONS

I used Nikki Tinkler's technique of quilting with embroidery stitches
(see Further Reading on page 118) as inspiration for these sumptuous silk cushions
in peacock colours. By using different quilting methods and varying the stitching
threads, you can use the same knot design to create four totally different effects –
and the quilted design is further enhanced by the sheen of the silk dupion.
Each cover is made up in the same way; I've used the royal blue one to
show you the first stages of preparing the design for stitching.

M A T E R I A L S

For all covers:
• Compressed wadding (batting) 48cm (19in) square
• Sewing thread to match the silk
• Cushion pad 45cm (18in) square
• Tracing/layout paper 45cm (18in) square
• Black felt-tip pen

For the emerald green cover:
• Emerald green silk dupion, one 48cm (19in) square
 and two rectangles 48 x 35cm (19 x 14in)
• Green quilting thread and suitable quilting needle
• White or pale green pencil crayon

For the pale aqua cover:
• Pale aqua silk dupion, one 48cm (19in) square
 and two rectangles 48 x 35cm (19 x 14in)
• Variegated green coton à broder or similar thread
 and suitable quilting needle
• Aqua pencil crayon

For the turquoise cover:
• Turquoise silk dupion, one 48cm (19in) square
 and two rectangles 48 x 35cm (19 x 14in)
• Royal blue coton à broder or similar thread
 and suitable quilting needle
• Blue pencil crayon
• Bodkin or tapestry needle

For the royal blue cover:
• Royal blue silk dupion, one 48cm (19in) square
 and two rectangles 48 x 35cm (19 x 14in)
• Purple/pink variegated coton à broder or similar
 thread and suitable quilting needle
• Pale blue pencil crayon

Producing the Design

1 Measure and draw the horizontal and vertical centre
lines on the square of paper. Lay the paper over the
knotwork design template (Fig 1 on page 25), aligning the
centre point of the square with the centre point on the
drawing, so the design fits into one quarter of the square.
Trace the lines in pencil, then trace the design into each of
the other quarters in the same way, to produce a complete,
full-size knot on the paper (as Fig 2 on page 25). Go over
the lines with black felt-tip pen to make them stronger.

2 Fold the square of silk into quarters, press the folds
and mark the centre point with a pin. Unfold the
square and lay it over the knotwork tracing so that the
centre points match up and the folds of the silk align
with the horizontal and vertical lines on the drawing.
Pin together, then use the pencil crayon to trace all the
lines of the design on to the silk, as shown above.

3 Open out the square of fabric and carefully press
out the folds. Lay the marked square of silk, right
side up, on top of a square of wadding (batting) and
work a grid of vertical and horizontal lines of tacking
(basting) to hold the two layers together (see page 102).

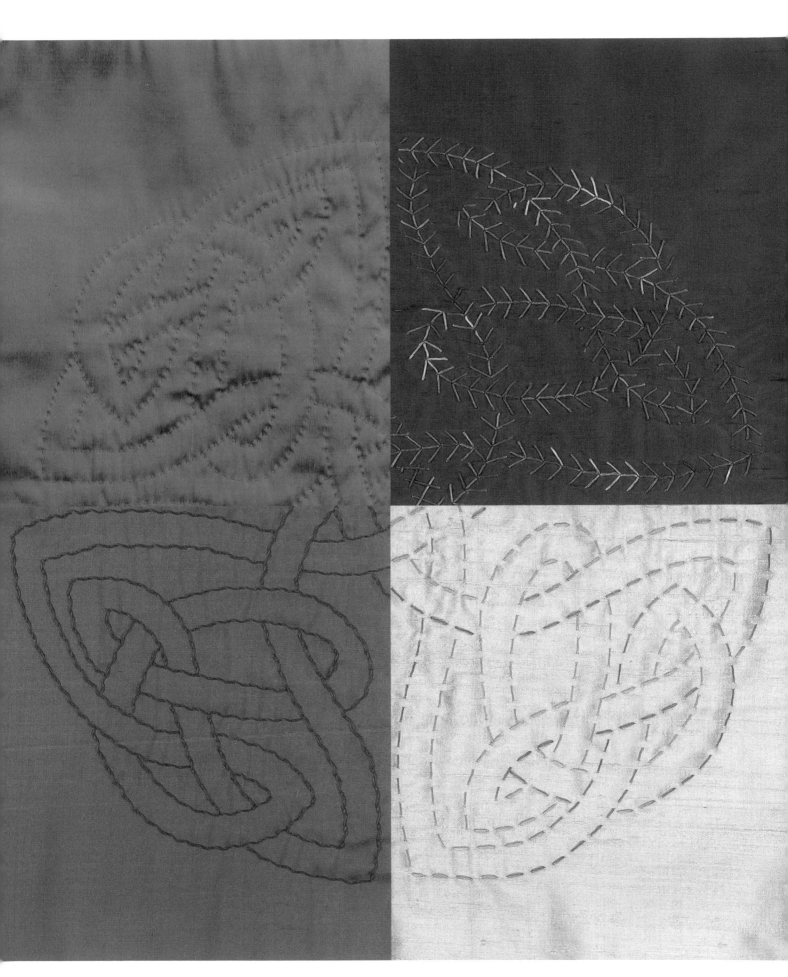

4 *For the emerald green cushion:* Work the design in hand quilting. Thread your needle with one strand of quilting thread and follow the general instructions for hand quilting on page 103, stitching along all the lines of the design.

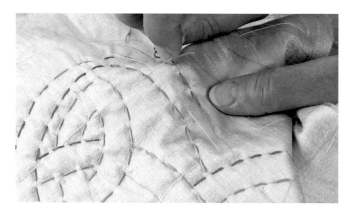

For the pale aqua cushion: Work the design in sashiko stitching. Thread your needle with one strand of variegated coton à broder, then follow the general instructions for sashiko stitching on page 104 to stitch along all the lines of the design.

For the royal blue cushion: The complete design consists of two separate knots: one knot fills the top right and bottom left of the design; the second fills the top left and bottom right. One knot is worked in herringbone stitch and one in fern stitch (see page 25). Thread your needle with one strand of the variegated thread and work the herringbone stitch first to fill the lines of one of the knots, following all the overs and unders. Once this knot is filled, work fern stitch inside the lines of the other knot.

5 Once you've completed your chosen quilting technique, remove the tacking (basting) threads and follow the instructions for making up a cushion cover on page 109 to complete the project.

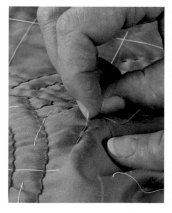

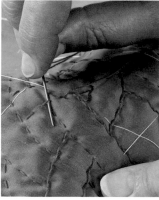

For the turquoise cushion: Work the design in whipped running stitch (see page 25). This is worked in two stages: use one strand of coton à broder to work a line of running stitches along all the lines of the design, then whip the stitches with a second strand.

Variation

Add a few beads or sequins to your finished design for a cushion with extra glitz.

Whipped Running Stitch

Following the diagrams, work a line of even, medium-length running stitches (a). Thread a bodkin or tapestry needle with a second thread and slip the needle under each running stitch in the same direction each time (b).

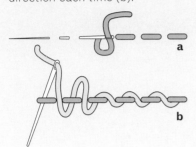

Herringbone Stitch

Following the diagrams, work from left to right along the stitching line. Make a small stitch from right to left below the stitching line (a), then follow this with a similar stitch above the stitching line (b).

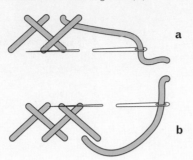

Fern Stitch

This simple stitch consists of three straight stitches, in a fan shape. Follow the diagrams, beginning with a central stitch (a), followed by a diagonal stitch to each side (b and c). Work the next central stitch to join the previous one.

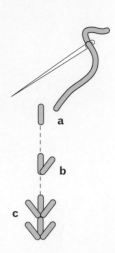

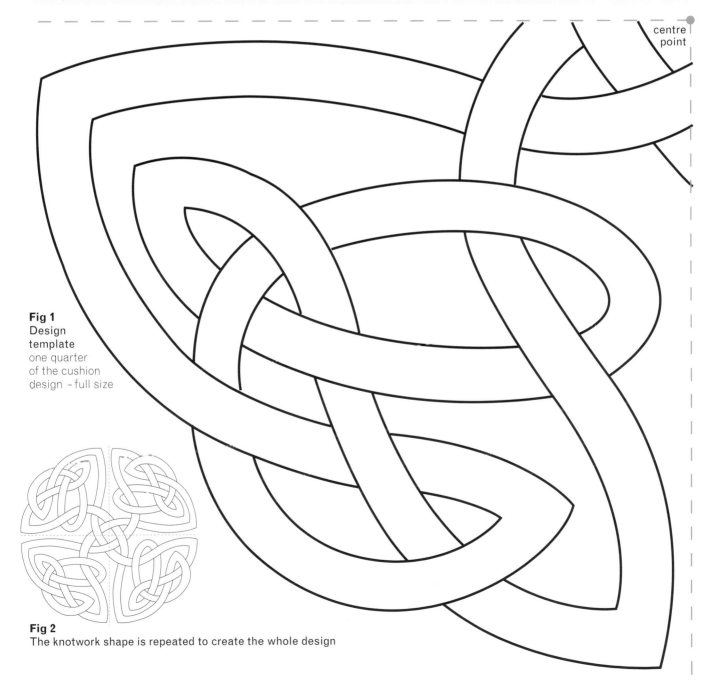

centre point

Fig 1
Design template
one quarter
of the cushion
design – full size

Fig 2
The knotwork shape is repeated to create the whole design

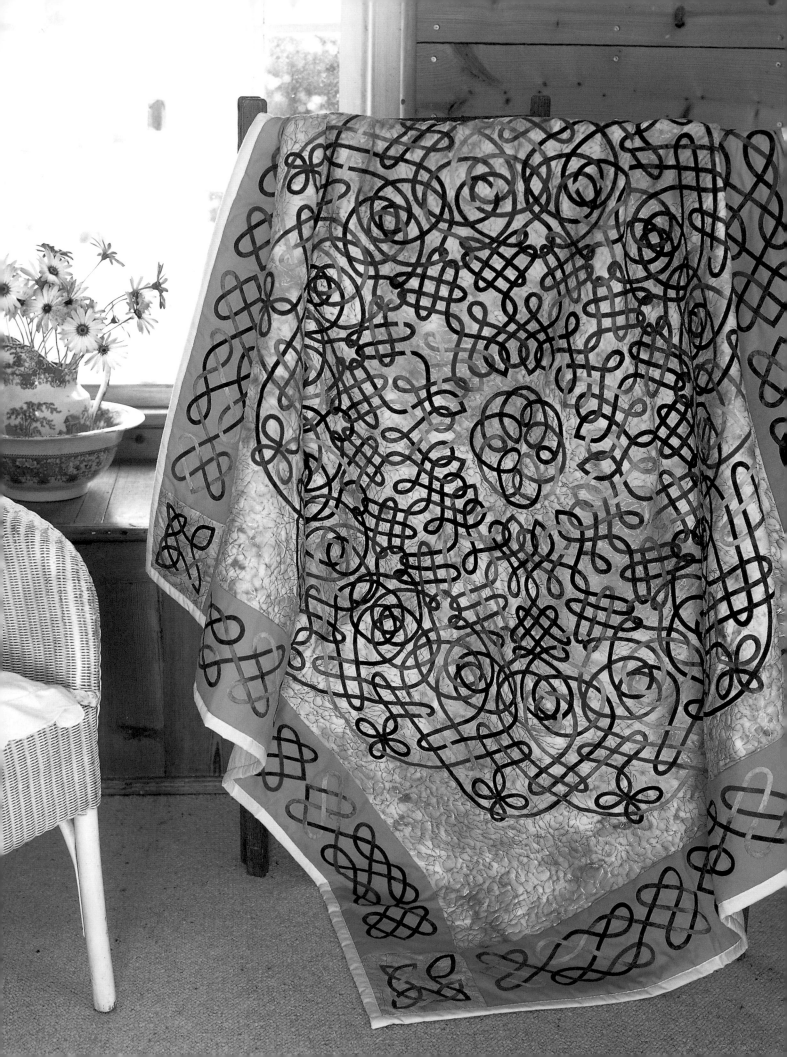

MULTICOLOURED KNOT WALL HANGING

Here is the pièce de résistance to finish off this section – a spectacular knot, formed from multicoloured bias binding, creates the centrepiece of a patchwork hanging, with borders and cornerpieces formed by other knots complementing the main pattern. The centre is a simplified version of a Celtic-inspired lace design by Leonardo da Vinci; I've designed my own border and corner knots to frame the centrepiece.

Easiness Rating
Challenging ☆☆☆
The basic technique itself is easy, but the complexity of the main knot means that this is not a project for the fainthearted!

Techniques Used
Bias binding appliqué
Simple machine quilting (optional)
Simple patchwork
Using fusible bias binding (optional)

Finished Size
135cm (53in) square approximately

M A T E R I A L S

- Printed background fabric, one 108cm (42in) square and four 18cm (7in) squares
- Contrasting plain fabric, four strips 108 x 18cm (42 x 7in)
- Compressed wadding (batting) 135cm (53in) square
- Toning backing/binding fabric at least 145cm (57in) square
- Extra strip of backing fabric for a casing
- Multicoloured bias binding, 90m (100yd) x 5–6mm (¼in) wide
- Tracing/layout paper 108cm (42in) square
- Black felt-tip pen
- Sewing thread to match the print fabric
- Your choice of hand or machine quilting thread

Producing the Design

1 Create the main knot tracing using a photocopier to enlarge the design template for one quarter of the knot (Fig 1 on page 28) to 50cm (20in) square; each square on the design should end up measuring 10cm (4in) square.

2 Measure and draw in the central horizontal and vertical lines on the large square of paper. Lay the paper over the enlarged design so that the centre points match and the straight lines on the paper align with the straight lines on the design, and the knotwork design fills one quarter of the paper. Use a pencil to trace all the lines of the design, then trace the design into the other three quarters of the paper in the same way to produce the complete circular knot.

3 Trace the small circular knot design template (given full size in Fig 2 on page 29) into the centre of the traced design. Go over all the lines with black felt-tip pen to make them stronger.

4 Fold the print fabric into quarters, press the folds and mark the centre point with a pin. Unfold the fabric and lay it over the complete design, matching the centre points and aligning the folds with the straight lines on the paper. Pin the two layers together firmly, then use a pencil to trace all the lines of the design carefully on to the fabric. (If your fabric is quite dark, you may need to use a lightbox for this stage – or you can tape the design on to a large window on a sunny day so you can see the lines through the fabric.)

5 The next stage is to add the bias binding to the circular knot. In the sequence on page 32, I use the small central knot to make a pincushion, to show you how the design is built up if you use fusible bias binding.

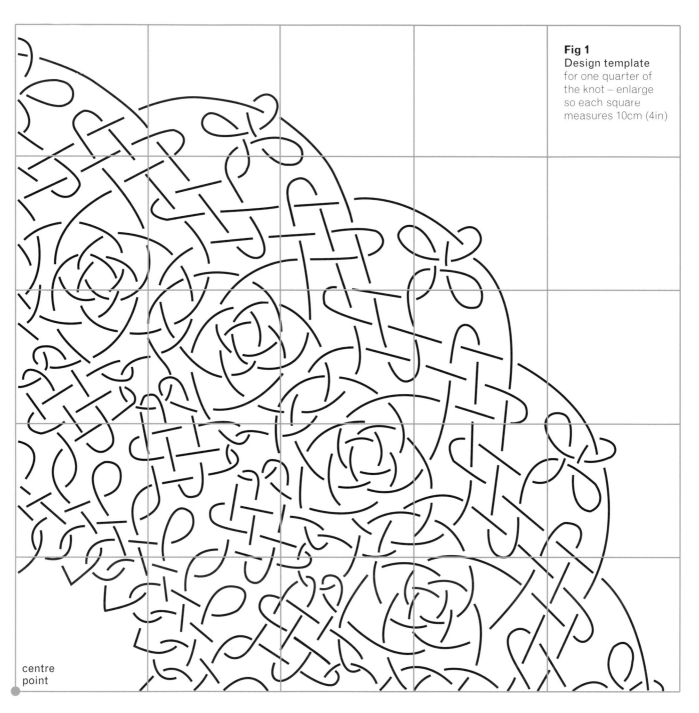

Fig 1
Design template for one quarter of the knot – enlarge so each square measures 10cm (4in)

centre point

If your binding isn't fusible, follow the same sequence but secure the binding with pins or tacking (basting) stitches as you position it. Build the design up in sections. Begin with the small central knot, shown as a pink line in Fig 3, securing and stitching it before you move on to the next part of the design. Use a small hand slipstitch (see page 102) to secure each edge of each line of bias binding.

6 Next, add the blue line shown in Fig 3; fuse or pin/tack (baste) it in place and begin stitching. Wherever the design shows that another line of binding goes underneath the one you're working on, take the sewing thread to the back, skip about 1.5cm (½in) of the edge of the binding where the line goes under it and then carry on stitching beyond (see Fig 4).

Fig 4

background fabric

bias binding

stitching with gap left

pencil line

7 Add the second line that makes up the outside of the knot (in yellow in Fig 3). Take it over and thread it under the previous line as indicated on the traced design. Stitch all the edges of all the lines of binding in place as you go.

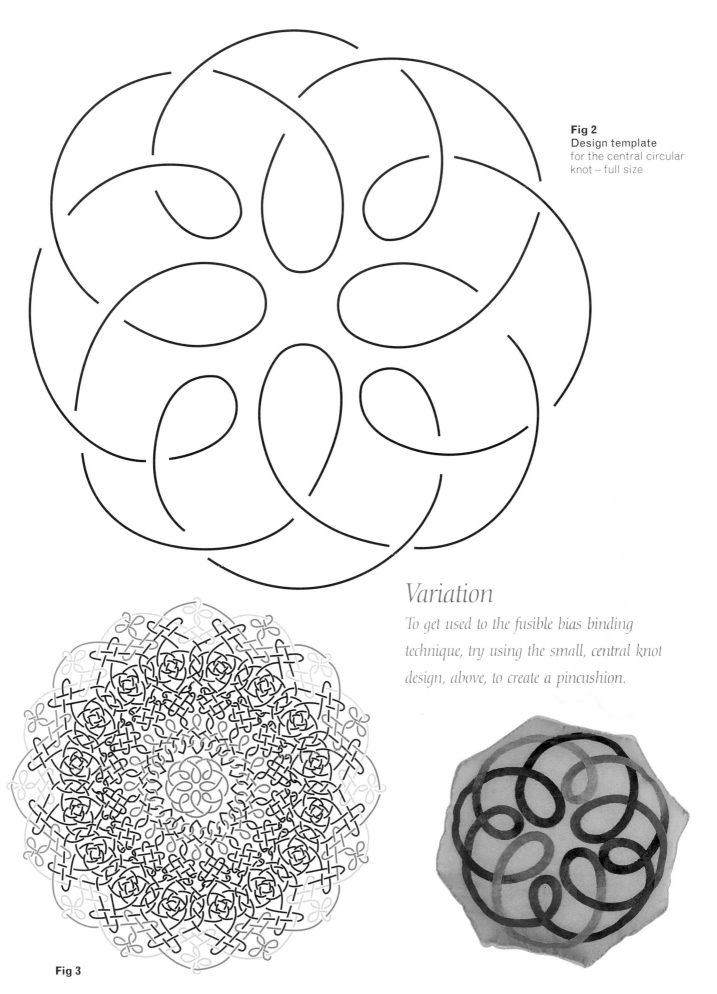

Fig 2
Design template
for the central circular
knot – full size

Variation

To get used to the fusible bias binding
technique, try using the small, central knot
design, above, to create a pincushion.

Fig 3

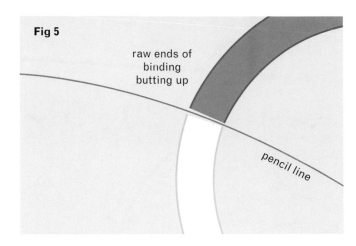

Fig 5

raw ends of
binding
butting up

pencil line

8 Add the orange line shown near the centre of the knot in Fig 3, leaving gaps as before where another line of binding goes under this one on the design.

9 Take a deep breath, and begin the rest of the knot! Work with lengths of binding about 2m (2yd) long, fusing/pinning/tacking the binding in place, then stitching that section before you carry on. Once again, pay careful attention to the overs and unders, and leave gaps for any unders as before. End and begin each length of binding at a place where the line you're covering goes under another line (see Fig 5). Work your way round the design, following the line of the knot and threading each length of binding over and under as appropriate, until the knot design is complete.

Fig 7

Fig 8

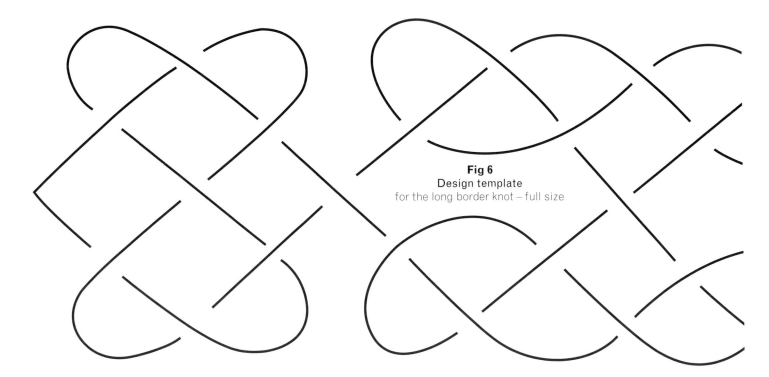

Fig 6
Design template
for the long border knot – full size

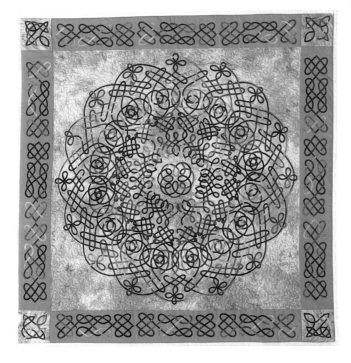

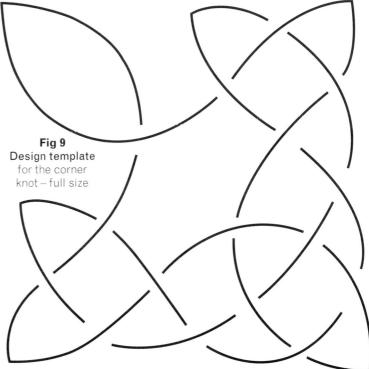

Fig 9
Design template
for the corner
knot – full size

10 To create the border strip knots, start by folding each strip of toning fabric in half across its width, pressing the folds then unfolding. On one strip, position the fabric right side up over the border design template (Fig 6 below), matching the centre lines and making sure there is an even border of fabric on each side of the knot. Trace the design in pencil on to the fabric as shown in Fig 7. Once this knot is complete, trace another knot at each end of the first one so that the tips of the designs almost touch (Fig 8).

11 Repeat this process with each of the other three border strips. Add the binding to the knots and stitch in place as before.

12 Trace the corner knot design template (Fig 9 above) on to the centre of each small square of print fabric, then add and secure the binding in the same way. Press all the designs from the back, using a steam iron if the fabric has pulled at all as you stitched.

HANDY HINT

Even if you're making your own bias binding, there are various gadgets on the market that will allow you to add a strip of bonding web to the back of the binding, so it's still fusible.

Piecing the Quilt Top

13 Join one border strip to each side of the central square (Fig 10), matching the centre lines of the middle border designs and the large knot. Join the square designs to each end of the remaining strips (Fig 11). Check the length of each border strip against the main design to ensure that the seams match, adjusting the position of the seams slightly if they don't quite align. Now join the remaining border strips on to the top and bottom of the main design (Fig 12).

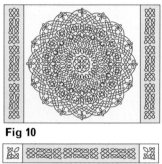

Fig 10

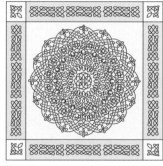

Fig 11 **Fig 12**

14 Lay the backing fabric right side down on a large, flat surface and lay the wadding (batting) on top so there is an even border of fabric all the way around the wadding. Position the design on top, right side up. Work a grid of horizontal and vertical tacking (basting) stitches (see page 102) across the fabric to hold the layers together. Quilt the plain areas of fabric around the central knot using your chosen hand or machine method – I've used very simple vermicelli (stipple) quilting by machine (see detail picture left, and also Fig 14e on page 104). The knot itself is very decorative so you don't need lots of quilting to show it off.

15 Fold the backing fabric to the front of the quilt in a double fold to create a narrow binding and stitch in place by hand or machine. Add a casing (see page 99) on the back of the quilt for hanging.

Variation

The long knots would make an effective edging for a pair of curtains; use as many whole repeats as you can fit into the width or length of the curtain edges.

Using Fusible Binding

1 Draw the design on to the fabric in pencil (A). Peel the backing paper off the beginning of a strip of fusible binding (B). Lay the binding, web side down, on a part of the design where one line goes under another. Fuse into place with a warm iron (C).

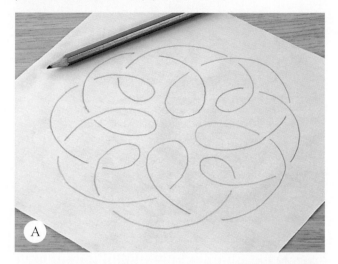

A

B

C

2 Continue laying the binding along the lines of the design (D); if you work round this particular knot in the direction shown, you'll find that the 'overs' of the pattern enable you to cover the first line with a series of loops. When you reach your starting point, cut the binding and fuse it in place so that the two raw ends butt up (E).

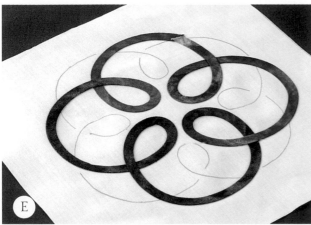

3 To begin the second line of the design, tuck the raw end of the next length of bias binding under an appropriate part of the design (F), then continue pressing this line of binding in place.

4 When you reach a part of the design where the new line goes under the original line, lift the first line away from the fabric with a finger, slip the new length of binding underneath (G), and press the first line back into place.

5 Carry on in the same way until all the lines of the design are covered (H). To secure the binding permanently to the fabric, work small slipstitches (see page 102) along the edge of each piece of binding (I).

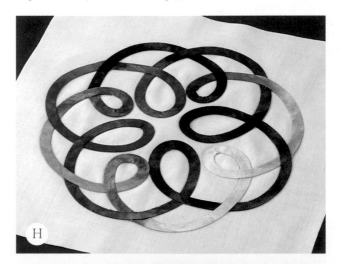

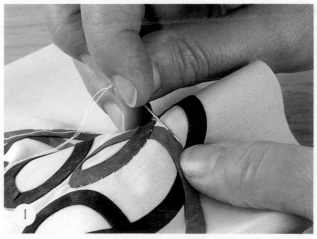

SPIRALS

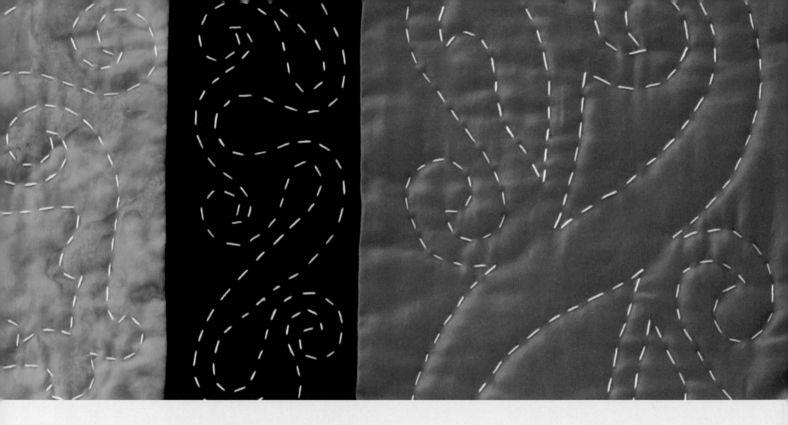

Spirals are found in many different forms in Celtic art, both on their own and in combination with knots, animal designs and fret patterns. As with knots, spirals can be made to fill almost any shape, which means they're versatile as well as striking. In this section of the book I've taken inspiration from various different types of Celtic spiral and created my own patterns to adorn a variety of items – from a simple spiral knot suitable for a glasses case to a bright Amish-style lap quilt. You'll probably be able to think of lots of other uses for the designs.

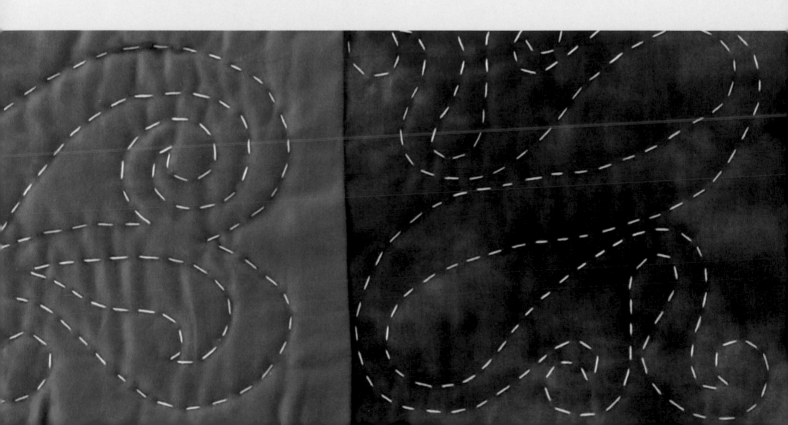

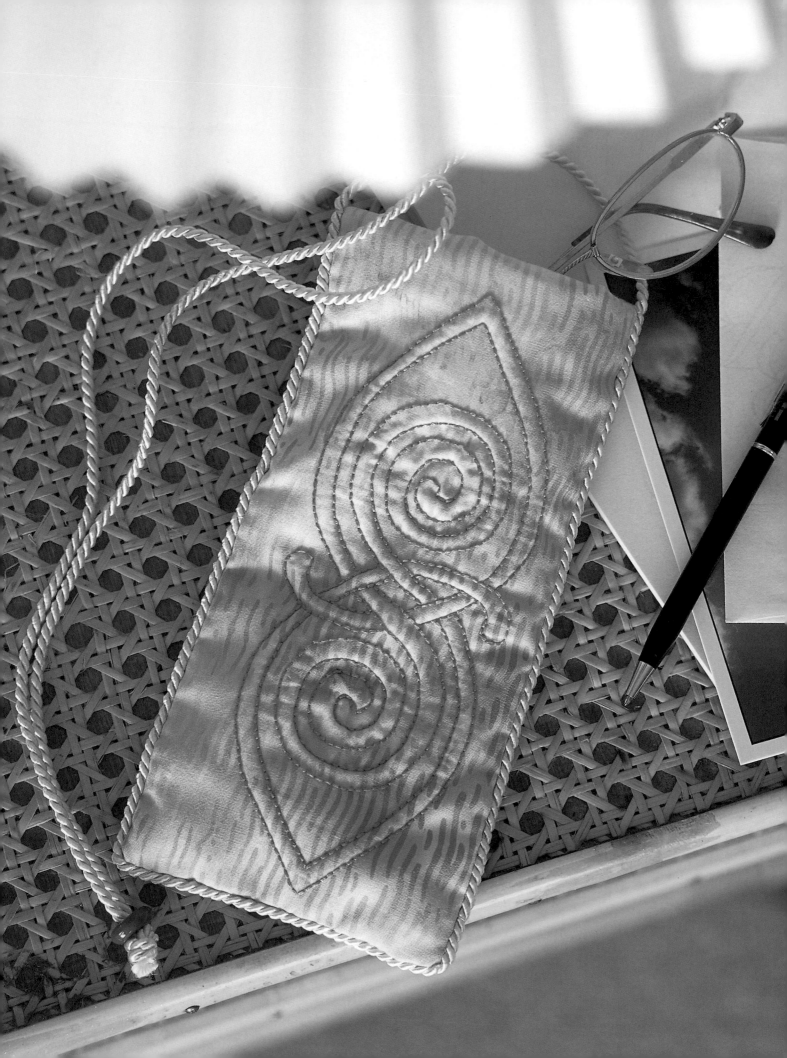

GLASSES CASE

Keep your glasses ready to hand in a padded glasses case that also shows off an unusual double-spiral knot. Simple corded quilting makes the motif stand out, while padding the case softly with a layer of compressed wadding (batting) helps to keep your glasses safe. Pick a fabric for the case that tones with the colours in your wardrobe or make a couple of cases in different colour schemes.

Easiness Rating
Easy ☆
The design is small, the technique very straightforward

Techniques Used
Backstitch
Italian (corded) quilting
Basic machine sewing

Finished Size of Design
21.5 x 10cm (8^1/$_2$ x 4in)

M A T E R I A L S

- Cotton print fabric 45 x 13cm (18 x 5in)
- Toning lining fabric 45 x 13cm (18 x 5in)
- Compressed wadding (batting) 42 x 10cm (17 x 4in)
- Firm white cotton backing fabric 22.5 x 13cm (9 x 5in)
- Sewing needle and bodkin
- Small amount of tapestry wool (yarn) in white or cream
- Skein of stranded embroidery thread to contrast with print fabric
- Pencil crayon to match embroidery thread
- 1.5m (1½yd) cord to match or contrast with print fabric
- Sewing threads to match print fabric and cord
- Large bead or toggle for the cord (optional)

Variation

Repeats of this design would work well along the border of a quilt, or down the lapels and along the hem of a jacket.

Producing the Design

1 Press the strip of print fabric, fold it in half across the width and press the fold. Open the fabric up and lay one half of it over the design template Fig 1 on page 38, right side up, so the design is centred in one half of the fabric strip. Use the sharp pencil crayon to trace all the lines of the design on to the fabric.

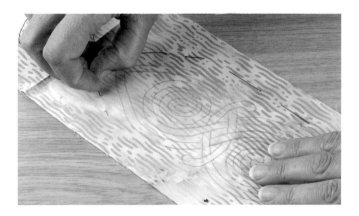

2 Lay the rectangle of white fabric behind the marked half of the print fabric strip and tack (baste) the two layers together.

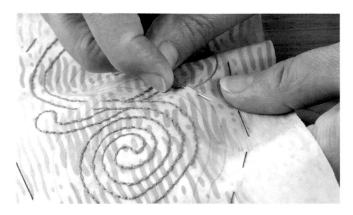

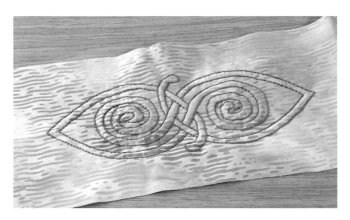

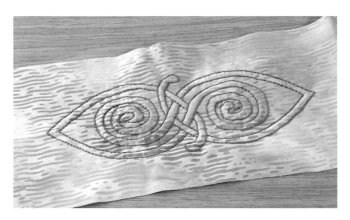

3 Using your chosen embroidery thread, work a line of even backstitch (see page 101) around all the marked lines of the design. When all the stitching is complete, remove the tacking (basting).

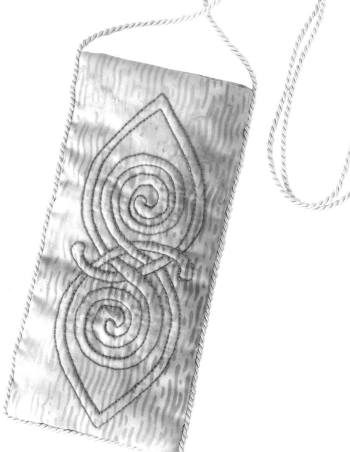

Variation

If you're feeling adventurous, you could work a second design – the same, or different – on the other side of the case.

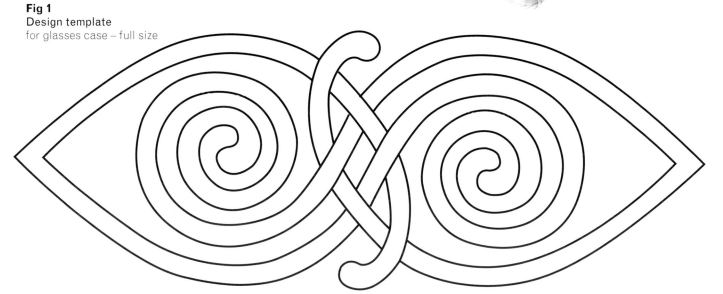

4 Once all the lines are stitched, follow the directions on page 108 to thread the channels with a single strand of tapestry wool (yarn). Use a bodkin for the threading as the blunt tip makes it easier to thread the channels without piercing the front of the design.

Fig 1
Design template
for glasses case – full size

Making Up the Case

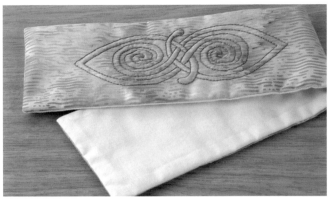

5 Lay the strip of lining fabric right side up on a flat surface and cover it with the stitched design, right side down. Position the wadding (batting) strip on top so there is an even border of fabric all the way around the wadding.

7 Slipstitch the opening closed. Fold the shape in half, right sides out, and work slipstitch or ladder stitch (see page 101) down the long edges to create the shape of the glasses case.

HANDY HINT

When you're attaching the cord, conceal the oversewing stitches by making sure that they lie along the twists in the cord.

6 Stitch a 1.5cm (½in) seam around all the edges of the rectangle, leaving about 15cm (6in) open on one side for turning. Clip the corners and turn the design out to the right side. Press the very edges of the rectangle to neaten them and to turn in the remaining seam allowances on the turning.

HANDY HINT

Use the point of a bodkin to push the corners out when you're turning the shape right side out as this creates crisp corners.

8 Measure the length for the cord – enough to go around the case, comfortably around your neck, plus a little extra to tie at the ends. Fold the cord in half, mark the halfway point with a pin and place this point at the bottom centre of the case. Stitch the cord to the bottom and edges of the case, using oversewing stitches. Knot the ends of the cord, or thread them through a large bead or toggle and knot them.

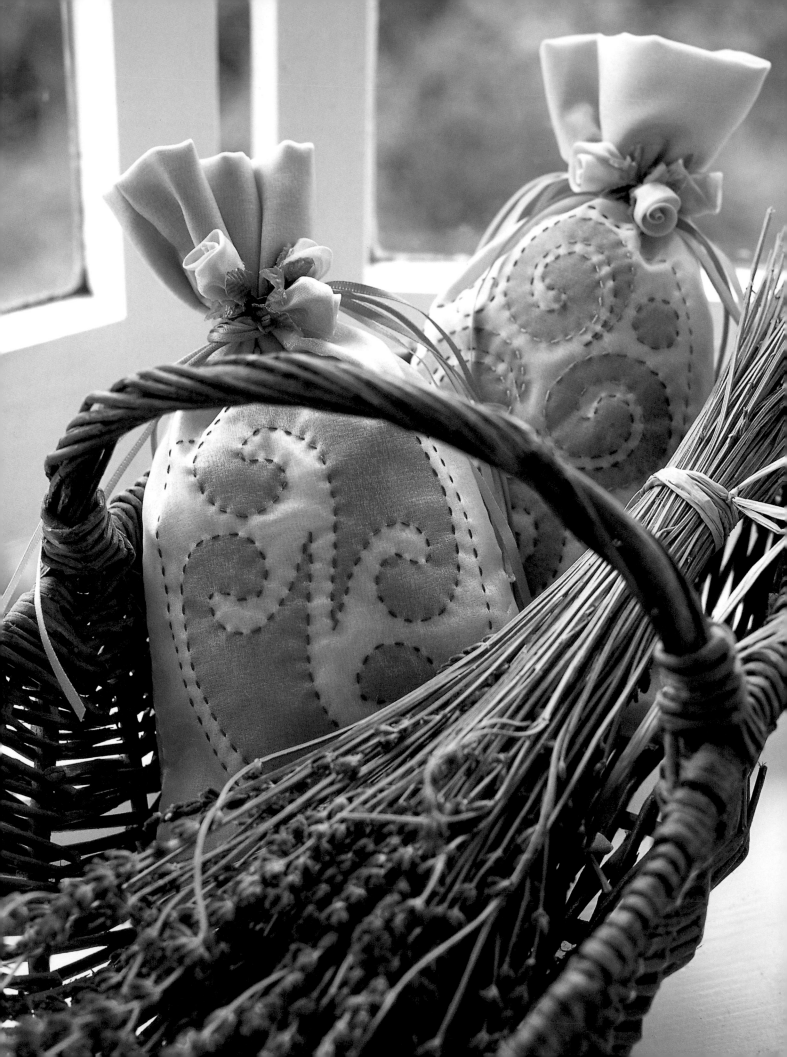

LAVENDER BAGS

Shades of mauve and green echo the colours of fields of lavender in these pretty, scented bags. The technique is shadow quilting, or shadow appliqué; a sheer top layer of fabric allows coloured shapes to be seen through it while the stitching securing the layers becomes a decorative part of the design. Knots of fine ribbons embellished with ribbon flowers add a lovely finishing touch. Try organza, tulle or silk net for the sheer layer.

M A T E R I A L S

For each bag:
• Sheer fabric 18 x 66cm (7 x 26in)
• Double-sided bonding web 15cm (6in) square
• Sewing needle
• Five or six fine ribbons in greens and mauves, roughly 50cm (20in) lengths
• Several ribbon flowers
• Sewing thread to match fabric
• Dried lavender or a mixture of polyester stuffing and lavender

For the green bag you will also need:
• Plain pale green cotton fabric 18 x 66cm (7 x 26in)
• Mid green cotton fabric 13cm (5in) square
• Small scrap of mauve cotton fabric
• Coton à broder or similar threads in variegated green and mauve
• Green and mauve pencil crayons

For the mauve bag you will also need:
• Plain mauve cotton fabric 18 x 66cm (7 x 26in)
• Mid purple cotton fabric 15cm (6in) square
• Coton à broder or similar thread in purple
• Purple pencil crayon

Producing the Design

1 Each design is produced in the same way, with the mauve bag used as an example. Fold the strip of fabric in half across its width and press the fold. Unfold, and lay the fabric right side up over the design template Fig 1A on page 42 (or Fig 1B for the green bag), so that the design is 2.5cm (1in) up from the fold and there is an even border of fabric at each side. Use the pencil crayon to trace the design on to the fabric.

2 Lay the bonding web, paper side up, over the reversed spiral motif given in Fig 2A on page 42 (or Fig 2B for the green bag). Trace the shape twice. Remember that the motif is reversed because you're tracing it on to the bonding web.

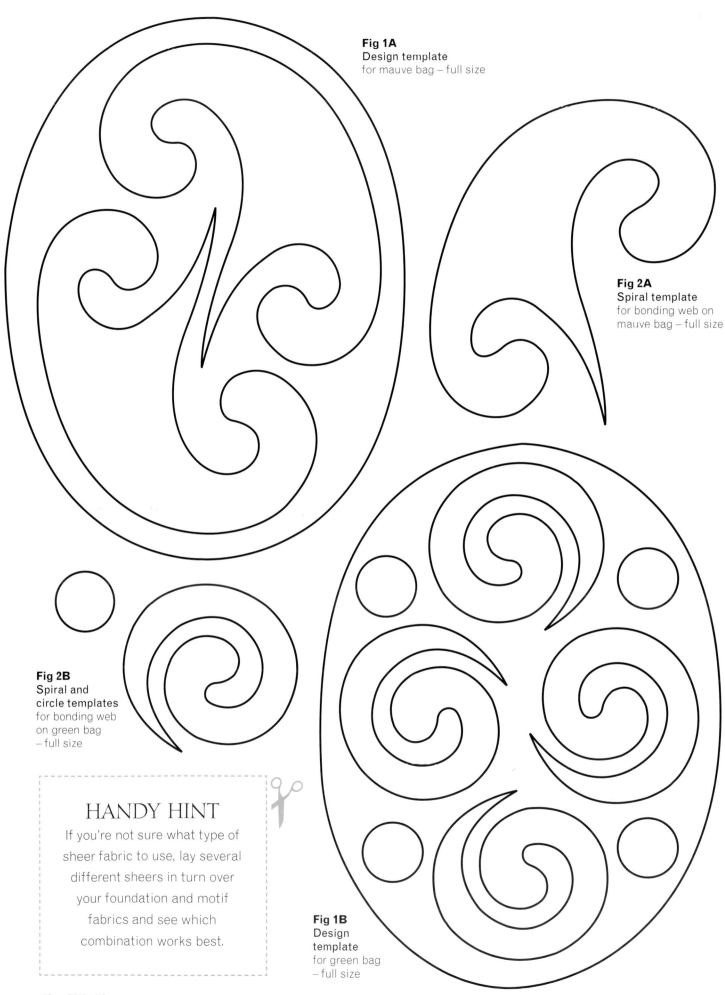

Fig 1A
Design template
for mauve bag – full size

Fig 2A
Spiral template
for bonding web on
mauve bag – full size

Fig 2B
Spiral and
circle templates
for bonding web
on green bag
– full size

Fig 1B
Design
template
for green bag
– full size

HANDY HINT

If you're not sure what type of
sheer fabric to use, lay several
different sheers in turn over
your foundation and motif
fabrics and see which
combination works best.

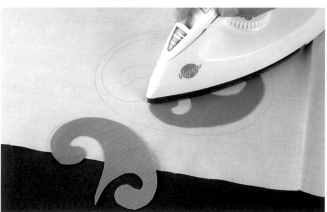

3 Fuse the bonding web, web (rough) side down, on to the wrong side of the purple fabric. Cut out the motifs. Peel the backing paper off the motifs, lay them in position on the traced design and fuse them into place.

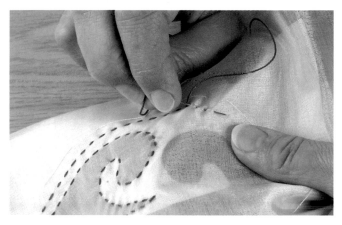

4 Lay the sheer fabric over the front of the mauve fabric strip and tack (baste) the two layers together around the edge of the design. Work a small, even running stitch (see page 101) around the oval border and the outlines of the motifs. When all the stitching is complete, remove the tacking (basting) thread.

Variation

Try these designs in jazzy colours on a bright waistcoat. If you cut the shapes from coloured felt, you won't need to secure them with bonding web.

Making Up a Bag

1 Fold your decorated strip of fabric in half, right sides together, and stitch a 1.5cm (½in) seam down each long side. Clip the corners and turn the shape right side out.

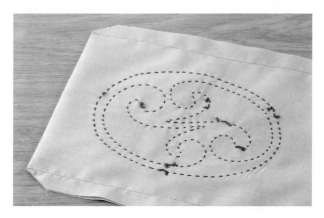

2 Fold the raw edges at the top of the shape down inside the bag, so that the bag is roughly 25cm (10in) high. Work a line of gathering stitches by hand or machine around the top of the bag, 5cm (2in) down from the top fold.

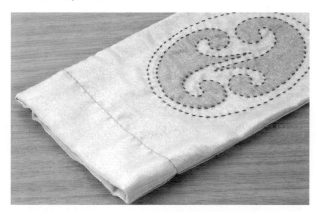

3 Fill the bag loosely with lavender, or a mixture of lavender and stuffing, then pull up the gathering thread to close the neck. Attach the ribbon flowers, then bundle the ribbons together and tie them in a tight reef knot round the neck of the bag.

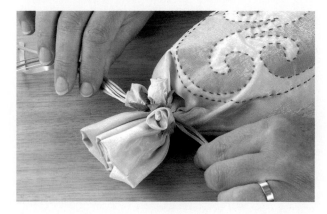

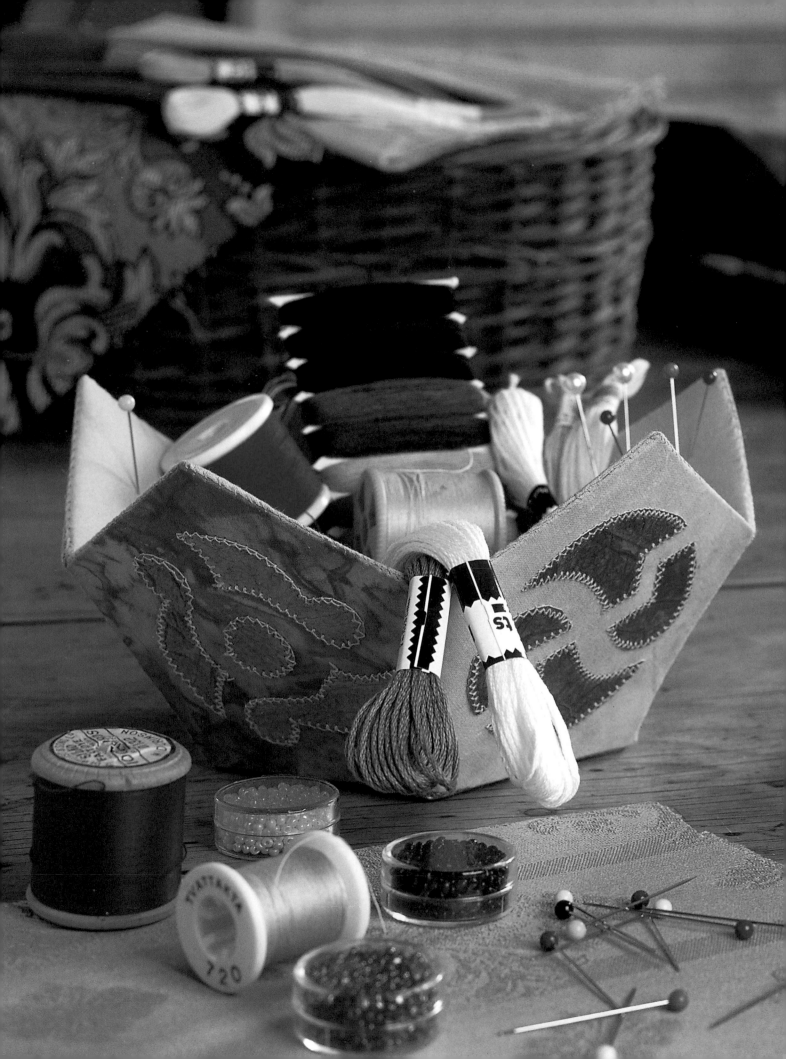

SEWING BASKET

This unusual basket will keep your threads in one place, along with thimble, tape measure, packets of beads and so on. The technique is a variation on traditional English patchwork, stretching the fabrics over cardboard instead of paper. The basket shape is created with pentagons instead of hexagons, each decorated with a different spiral – six pentagons for the bottom and six for the lid.

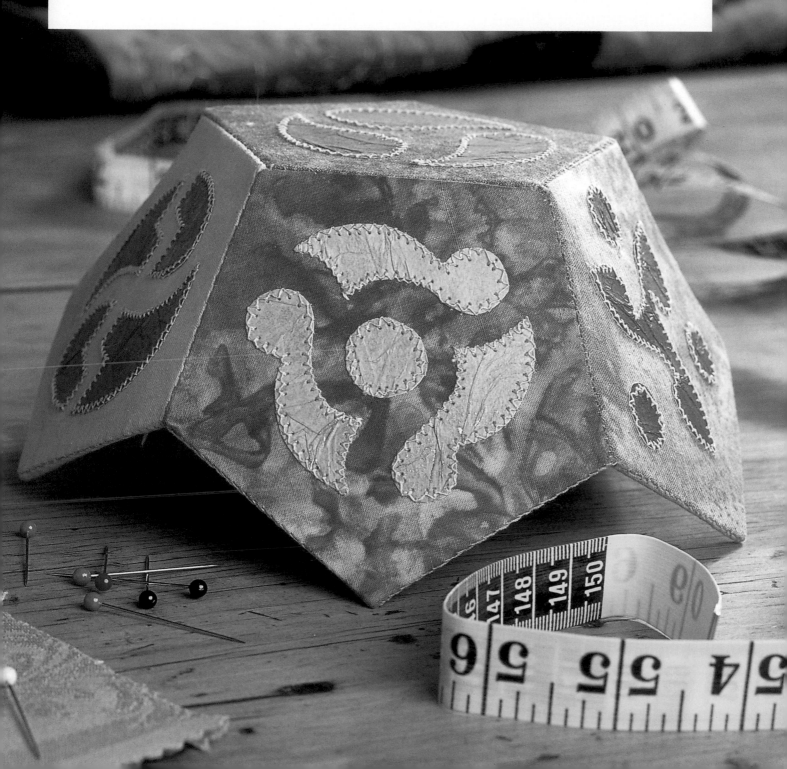

M A T E R I A L S

- Six different orange/yellow mottled or marbled cotton fabrics, two 15cm (6in) squares of each
- Plain yellow or orange cotton fabric 30 x 60cm (12 x 24in)
- Scraps of 2oz wadding (batting) about 30 x 60cm (12 x 24in)
- Firm cardboard such as mounting board, about 60cm (24in) square
- Textured papers or textured bonded fabrics in toning colours, about 22 x 45cm (9 x 18in)
- Sewing needle
- Sewing threads to tone with fabrics
- Stick glue

Producing the Design

1 Trace or photocopy the pentagon templates, Figs 1 and 2. Cut them out and use the larger template to cut two patches from each of the marbled cotton fabrics and twelve patches from the plain fabric. Use the smaller template to cut twenty-four pentagons from card and twelve from wadding (batting).

Fig 2
Small pentagon template – full size

Fig 1
Large pentagon template – full size

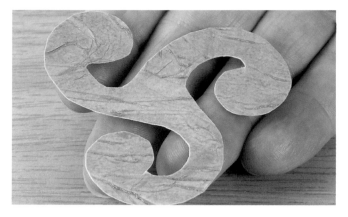
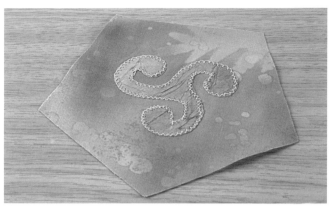

2 Trace or photocopy the six different spiral templates given in Fig 3 below and cut them out. Use each template (or set of templates, where there is more than one shape) to cut two patches (or sets of patches) from the textured paper or fabric.

3 Set your machine to a small zigzag stitch. Decide which fabric patch you want decorated with which motif then lay each patch right side up and position the motif, or set of motifs, centrally. Stitch all the way round each motif with zigzag to appliqué it to the background.

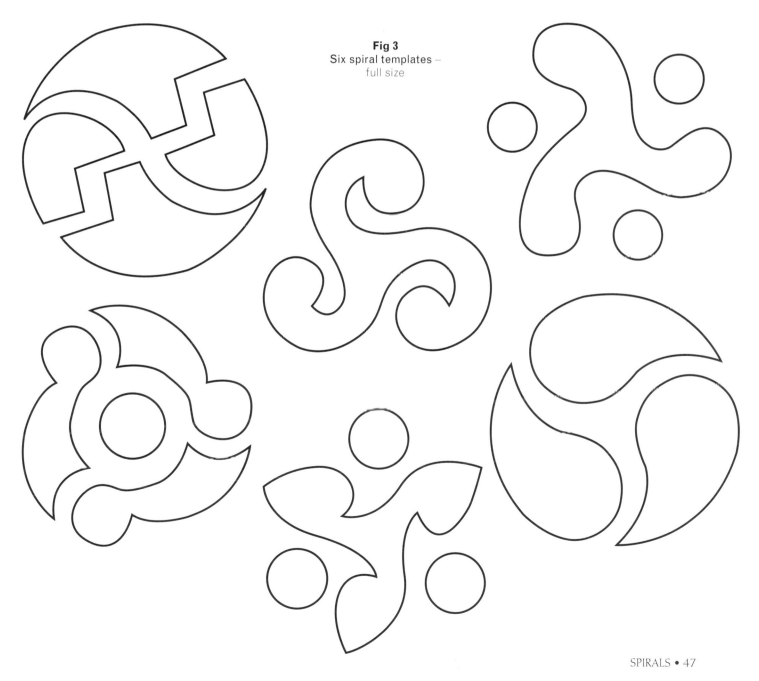

Fig 3
Six spiral templates –
full size

Making Up the Basket

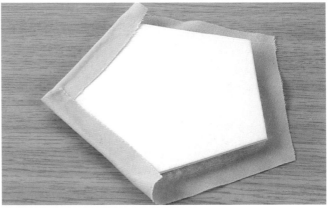

6 Lay one of the plain fabric pentagons right side down on a flat surface and position a card pentagon, wadding (batting) side down, on top. Fold the raw edges of the fabric over the card and glue in place. Do the same with all the other plain fabric patches.

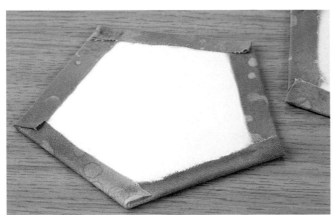

4 When each mottled/marbled fabric patch has been decorated, press it from the back. Lay one of the patches right side down on a flat surface and position a card pentagon in the centre, with an even border of fabric all the way around. Spread a little glue near each edge of the card shape and press the raw edges of the fabric patch firmly down over the glue to secure them. Do the same with all the other decorated patches.

HANDY HINT
Adding the wadding (batting) to the inside shapes means that you can use them as pincushions for your pins and needles.

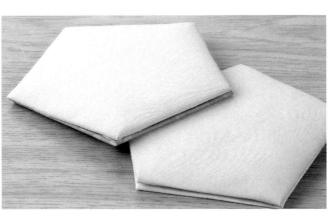

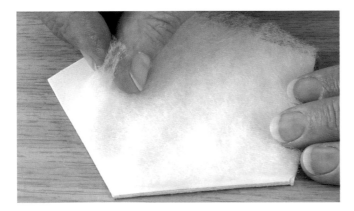

5 Take the remaining card pentagons, spread a little glue on the surface of each one and position a wadding (batting) shape on top. Leave to dry for a few minutes so the glue isn't too sticky.

7 Lay one decorated pentagon flat side down and spread glue over the card. Lay a padded pentagon shape on top, card side down, matching edges and points. Do the same with all the other decorated pentagons; you should now have twelve padded pentagon 'sandwiches' – two of each design. Divide them into two groups of six, one set for the basket bottom and one set for the lid.

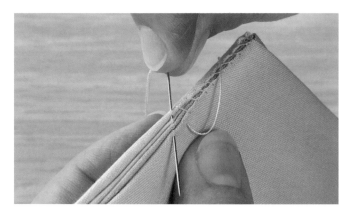

Variation

Any of these little spiral designs
would work well on a greetings card.
Try them out in different colours
and fabrics, perhaps using metallics.

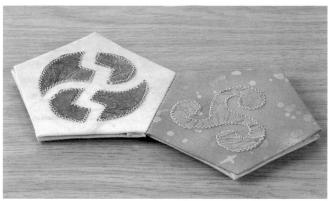

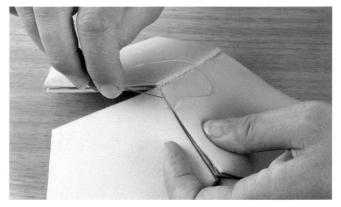

8 Take two of the pentagon shapes from one group and put them right (decorated) sides together so that their edges match. Oversew one straight edge together, making sure that the needle passes through the folded edges of all four fabrics. Finish the thread off strongly; you now have two pentagons joined along one edge.

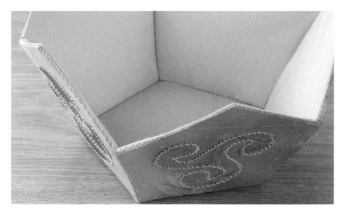

Variation

This project is a variation of
a traditional pattern for making
a baby's ball. If you want to use
the templates to create a stuffed ball,
decorate twelve fabric pentagons,
tack (baste) them over smaller paper
pentagons and stitch them all
together, leaving a couple of edges
open. Remove the tacking (basting)
and stuff – as you add lots of stuffing
the shape becomes a ball.

9 Add a second pentagon to the next edge of your central shape and continue around the central shape until you have attached five pentagons, one to each side. Work ladder stitch (see page 101) from the right side between adjoining pentagons, folding the patches up into a basket shape as you work. Finally, oversew the top, pointed edges of the shapes to finish the bottom of the basket. Use the remaining shapes to create the lid in the same way.

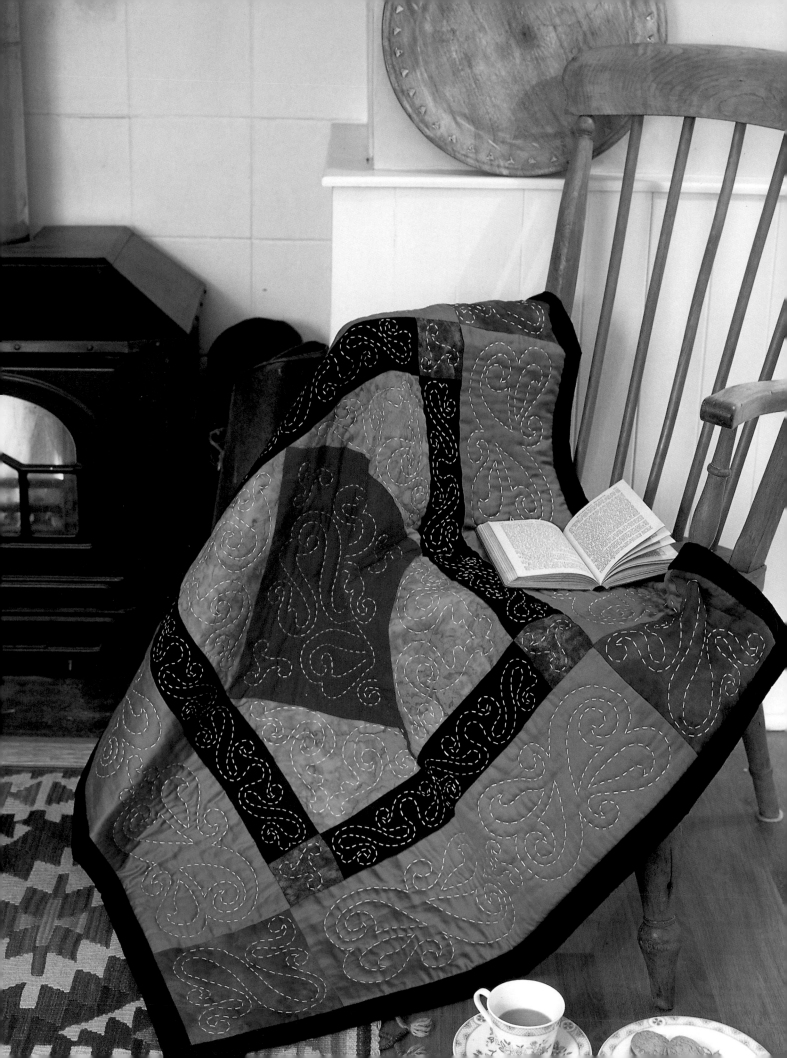

AMISH SPIRAL LAP QUILT

I've used the traditional colours and shapes of Amish quilts to create this lap quilt.
The Amish use bright, plain-coloured fabrics for dresses, often using scraps in quilts, set off
by the black of the men's clothes. I've chosen fabrics that are basically plain but some have
mottling or marbling to provide visual interest. The flowing spiral designs are from different
sources, adapted to have similar characteristics and quilted with big-stitch quilting.

Easiness Rating

Medium ☆☆

The piecing is relatively easy, and although there is a
lot of quilting it's done with big stitches and doesn't
take too long compared with conventional quilting

Techniques Used

Simple machine patchwork
Big-stitch quilting

Finished Size of Quilt

101cm (40in) square approximately

M A T E R I A L S

- Green cotton fabric 92cm (36in) square
- Purple cotton fabric 22.5cm (9in) square
- Red cotton fabric 50cm (20in) square
- Turquoise cotton fabric 50cm (20in) square
- Royal blue cotton fabric 50cm (20in) square
- Black cotton fabric 50cm (20in) square
- Black cotton backing fabric 112cm (44in) square
- 2oz wadding (batting) 102cm (40in) square
- Large sewing needle
- Two skeins of white coton à broder or sashiko cotton
- Sewing threads to match your bright fabrics, and black
- Sheets of newspaper, adhesive tape, long ruler, pencil
 and a felt pen
- Your chosen marking tool (see step 5)

Piecing the Quilt Top

Measurements are more critical in this project because
the sizes of the patches and accurate seam allowances
are important for putting the design together. As a
result, there are separate instructions for creating the
templates according to whether you're working in
metric or imperial.

1 *If working in metric:* Cut an accurate 101cm square
from newspaper, taping several sheets together if
necessary. Draw out the quilt design on the square,
following the metric measurements in Fig 1a. Cut out
shapes A, B, C, D, E and F and use these as templates to
cut patches from the appropriate fabrics as explained in
step 2, adding a 1.5cm seam allowance around each
edge of each template. Follow the piecing instructions
in step 3, taking a 1.5cm seam allowance each time.

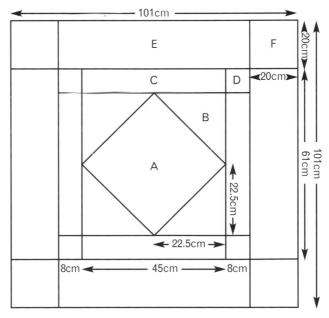

Fig 1a Dimensions for the templates (metric version)

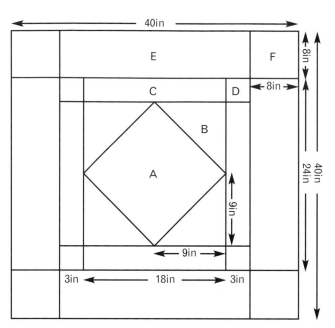

Fig 1b Dimensions for the templates (imperial version)

1 *If working in imperial:* Cut an accurate 40in square from newspaper, taping several sheets together if necessary. Draw out the quilt design on the square, following the imperial measurements in Fig 1b. Cut out shapes A, B, C, D, E and F and use these as templates to cut patches from the appropriate fabrics as explained in step 2, adding a ½in seam allowance around each edge of each template. Follow the piecing instructions in step 3, taking a ½in seam allowance each time.

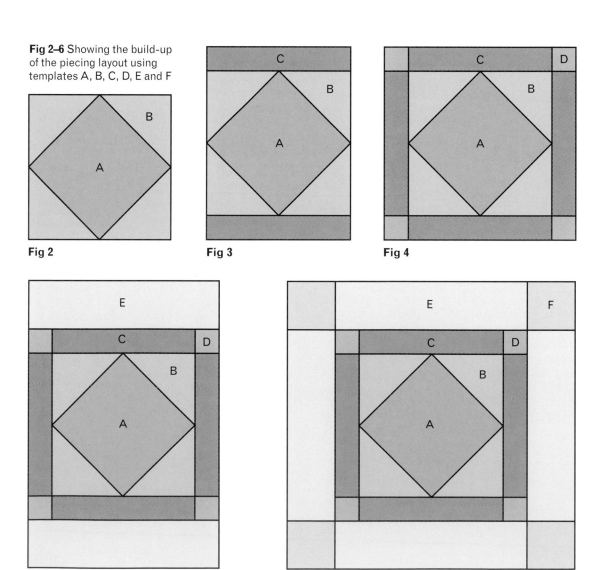

Fig 2–6 Showing the build-up of the piecing layout using templates A, B, C, D, E and F

Fig 2

Fig 3

Fig 4

Fig 5

Fig 6

2 For all these shapes, remember to add the appropriate seam allowance around each edge of each template.
Use template A to cut one square from the red fabric.
Use template B to cut four large triangles from the turquoise fabric.
Use template C to cut four strips from the black fabric.
Use template D to cut four squares from the purple fabric.
Use template E to cut four strips from the green fabric.
Use template F to cut four squares from the blue fabric.

3 Follow the sequence shown in Figs 2, 3, 4, 5 and 6 on page 52 to piece the quilt top. First join the long edges of the turquoise triangles to the central red square (Fig 2). Add a black strip to the top and bottom of this shape (Fig 3), then join a purple square on to each end of the remaining black strips and add these composite strips to the central shape (Fig 4). Add a green strip to the top and bottom of this new shape (Fig 5), then add a blue square to each end of the remaining green strips and add these composite strips to the central shape to complete your quilt top (Fig 6).

Marking the Quilting Designs

4 Trace or photocopy the spirals in Figs a, b, c, d, e and f (pages 53–57). The central design shows one quarter of the complete motif; trace four repeats next to each other, or stick four photocopies together, to create the whole motif. The letters on the different patterns (a–f) match the parts of the quilt top they fit into: e.g., two repeats of pattern c go on each black strip that you cut from template C. The three-legged spiral (pattern d) that is used for patch D is also used at the corners of the red square (patch A) and between the mirror-image motifs on the four green strips (patch E).

5 Mark the patterns on your quilt top – Fig 7 on page 55 shows the layout. Refer to page 100 for marking patterns; whichever method you use, check that the main design is centred in the red square and that the repeats of the design on the borders are level and even. Note that the repeats of pattern e on the green strips are mirror images so you'll need to turn the drawing or template over for the second motif on each strip.

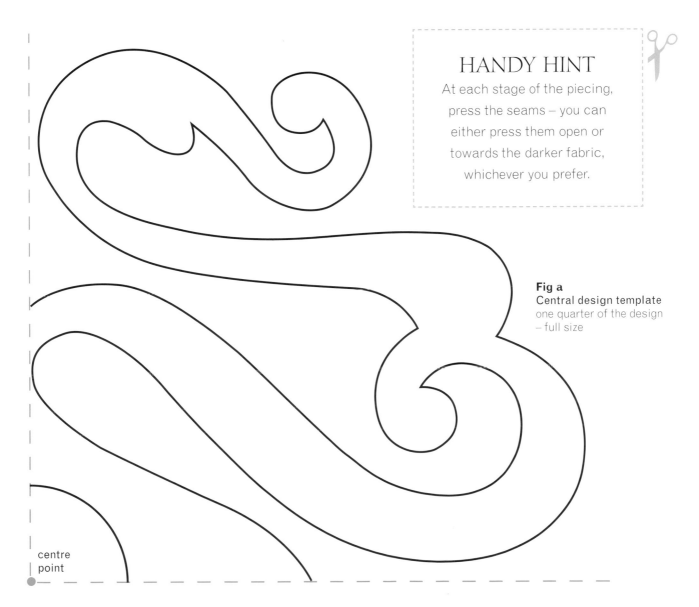

HANDY HINT
At each stage of the piecing, press the seams – you can either press them open or towards the darker fabric, whichever you prefer.

Fig a
Central design template
one quarter of the design
– full size

centre point

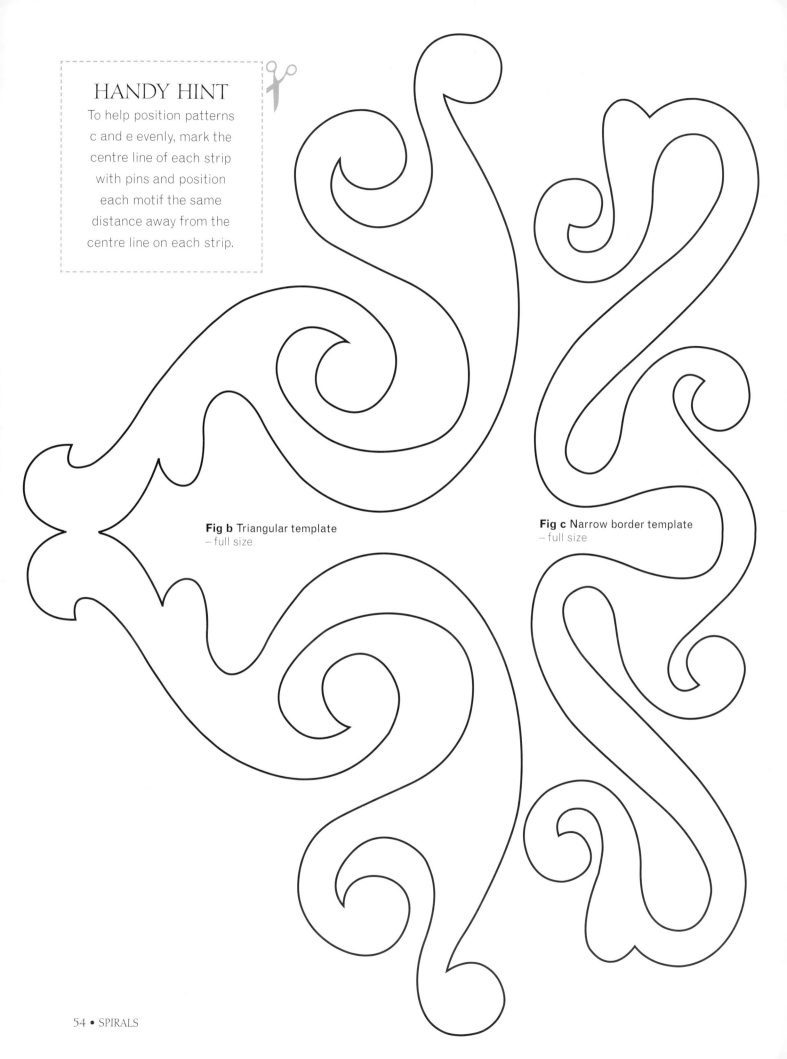

HANDY HINT
To help position patterns
c and e evenly, mark the
centre line of each strip
with pins and position
each motif the same
distance away from the
centre line on each strip.

Fig b Triangular template
– full size

Fig c Narrow border template
– full size

6 Once all the patterns have been marked on to your quilt top follow the instructions on page 102 to make your quilt 'sandwich' from the backing, wadding (batting) and quilt top. Now it's time to quilt!

Producing the Design and Finishing the Quilt

7 Beginning with the central design, and using big-stitch quilting (see page 104) in white thread, stitch around all the edges of the designs marked on the quilt top.

8 Once all the quilting is complete, remove any remaining markings if necessary (e.g., spray the quilt top with cold water if you've used water-soluble pen). Carefully neaten the edges of the wadding (batting) and quilt top if necessary, making sure that you don't cut through the backing, then fold the edges of the black fabric over to the front of the quilt in a double fold and stitch down by hand or machine.

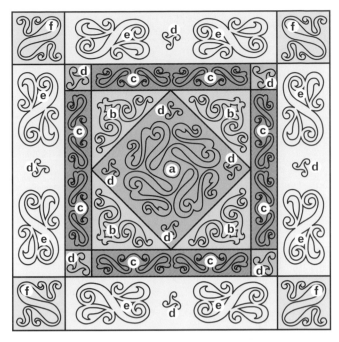

Fig 7 Layout of the different spiral quilting patterns

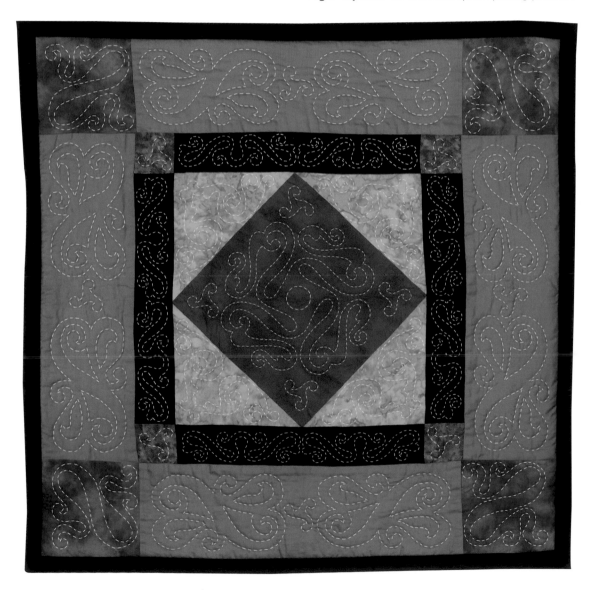

Fig e
Large border template –
full size (reverse for 2nd
half of each strip)

Fig d
Small spiral
template –
full size

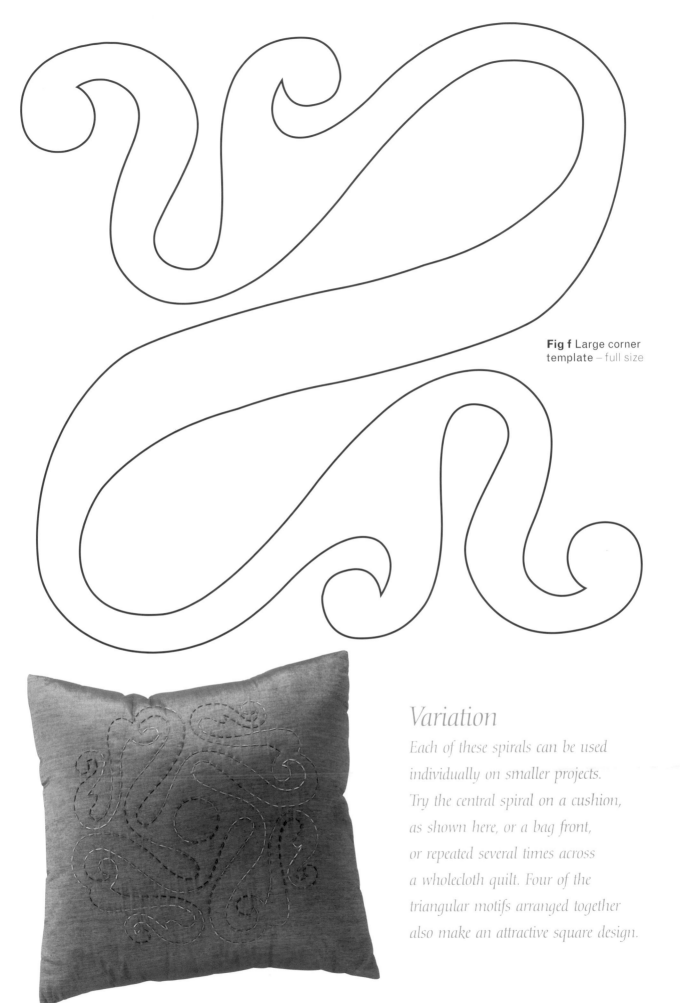

Fig f Large corner
template – full size

Variation

*Each of these spirals can be used
individually on smaller projects.
Try the central spiral on a cushion,
as shown here, or a bag front,
or repeated several times across
a wholecloth quilt. Four of the
triangular motifs arranged together
also make an attractive square design.*

FRET, KEY AND
CARPET PATTERNS

One aspect of Celtic design that is sometimes overlooked is the wealth of meandering, maze-like fret and key patterns. If you look at reproductions of Celtic art you'll often find these patterns used as fillers, tucked into circles, squares, rectangles, corners and triangles. Like most other designs from the same era, they range from very simple to enormously complex. I've used some of these fret and key designs as inspiration for the projects in this part of the book, and I've also included some inspiration from the magnificent carpet page designs seen in the illuminated manuscript gospels – geometric patterns which cover whole pages and look like complex carpets.

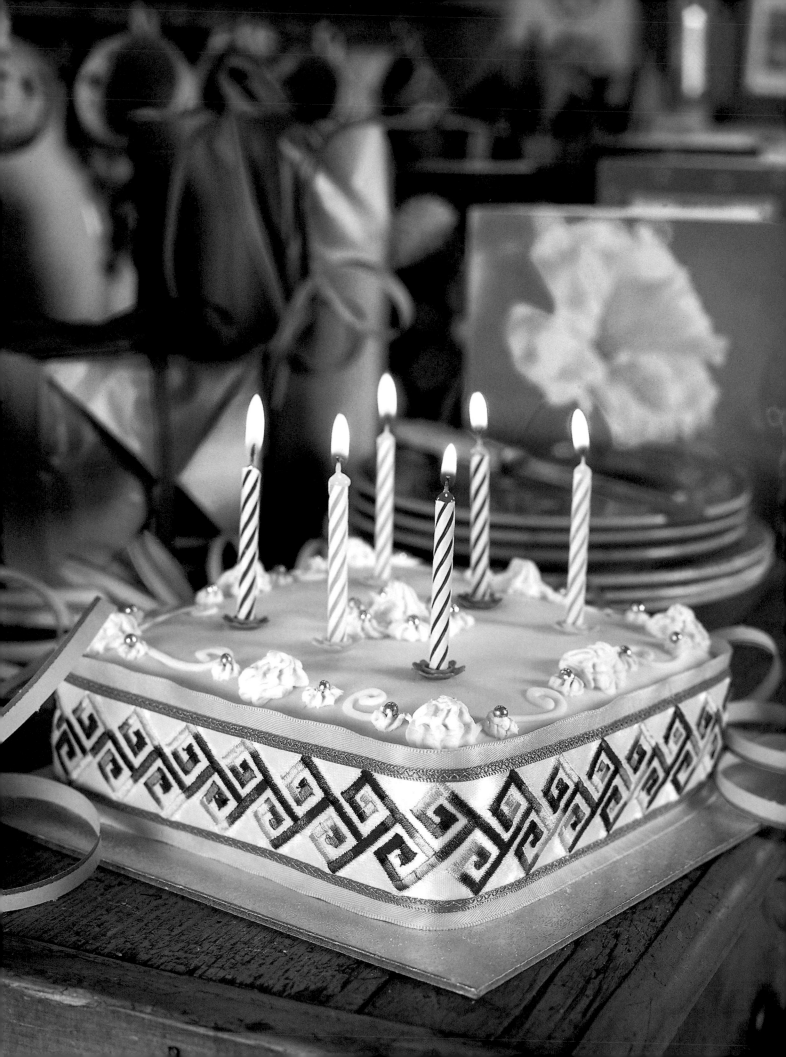

CELEBRATION CAKE RIBBONS

If you're not into fancy cake decorating, a stitched ribbon is the perfect way to dress up a plain cake. This design uses a simple Celtic key design, worked in machine satin stitch which simultaneously appliqués the top ribbon to the wider base ribbon. For the birthday ribbon I've used a multicoloured thread for an unusual variegated effect; you'll also find a Christmas design and a wedding cake ribbon on page 62.

Easiness Rating
Fairly Easy ☆
If you are confident with machine satin stitch

Techniques Used
Simple machine satin stitch appliqué
Simple machine or hand stitching

Finished Size of Ribbon
5cm (2in) wide

MATERIALS

For each ribbon:
- One length of satin ribbon, 5cm (2in) wide – measure your cake circumference and add 5cm (2in)
- One length of satin ribbon, 4cm (1½in) wide (length as above)
- Two lengths of fine ribbon, braid, lace or beading, plus matching sewing thread
- Two lengths of foundation paper at least 4cm (1½in) wide
- Machine-embroidery thread to contrast or tone with your ribbons
- Spray starch

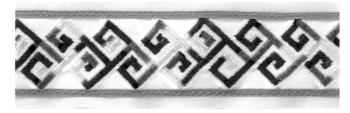

Producing the Design

1 Trace or photocopy the design template (Fig 1, page 62). If necessary, stick two tracings or photocopies together to reach the required length for your ribbon.

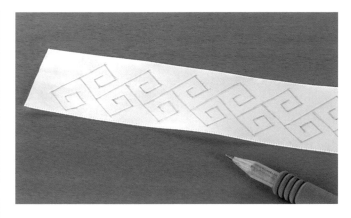

2 Spray the lengths of ribbon lightly with spray starch and press them. Lay the narrower ribbon right side up over the design tracing, pin in place and use a soft pencil to trace the lines of the design down the centre of the ribbon, then unpin.

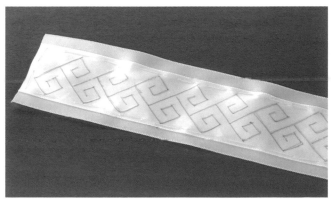

3 Lay the wider ribbon right side up on a flat surface and position the narrower ribbon, right side up, on top so that the wider ribbon shows an even border on each side of the narrower ribbon. Tack (baste) the two layers together, as shown.

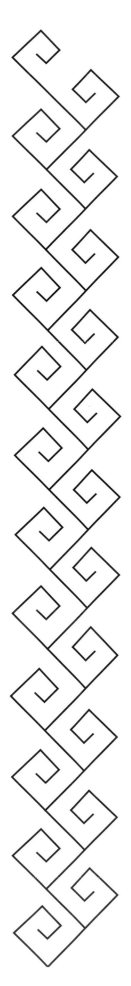

Fig 1
Design template
for cake ribbon – full size;
add more repeats to make
the design longer

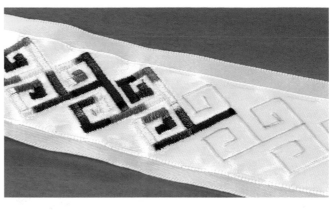

HANDY HINT

Using two layers
of foundation
paper helps to
stop the ribbon
distorting under
such a densely
stitched design.

4 Thread your machine with the embroidery thread and set to a satin stitch about 2.5mm wide. Position the two layers of foundation paper under the design and, following the instructions for satin stitch on page 63, carefully stitch along each section of the key design, building up the lines of stitching as shown in Fig 2. Keep the lines as straight as possible and the corners crisp and pull all loose threads through to the back as you go to create a neat effect on the front of the work.

Variations

Choose rich colours and gold thread for decorating a Christmas cake, or soft creams and beiges embellished with pearls for a wedding cake.

Fig 2 Order of stitching lines for the cake ribbons

Working Machine Satin Stitch

See page 105 for useful general tips on working machine satin stitch.

1 Begin by positioning foundation paper under the work and stitch an even satin stitch along each line of the design. Work as fast as you feel comfortable and can safely do while still being in good control of your machine – the faster you can stitch, the more even the satin stitch will be.

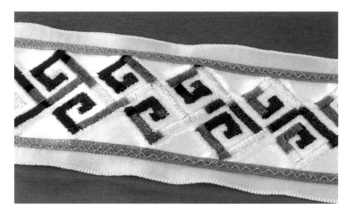

5 Once all the machine stitching is complete, remove the tacking (basting) threads and tear the foundation paper away from the back of the work. Lay a strip of narrow ribbon, braid or beading along each edge of the central ribbon and stitch into place by hand or machine, whichever is appropriate.

2 If the end of the line of satin stitch will be covered by a subsequent line you don't need to finish it off neatly but simply stop stitching and neaten the end of the first line with the later line of stitching. If it won't be covered by a later line, move the stitch width to zero once you've finished stitching and work a couple of stitches in place if you want the line to end with a straight edge.

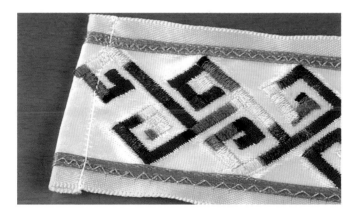

6 At each end of the decorated ribbon, fold 1.5cm (½in) to the back and stitch in place by machine. On the special day, wrap the ribbon around the cake and overlap the ends slightly, holding it in place with a couple of glass-headed pins through the ribbon and into the cake. Remember to remove the pins and ribbon before the cake is cut.

3 If you want the line to taper, slowly reduce the width of the stitch as you near the end of the line, until you finish with it at zero at the end of the line. Don't work reverse stitches over the line of satin stitch to finish them as this will look too bulky. When all stitching is finished, remove the foundation paper.

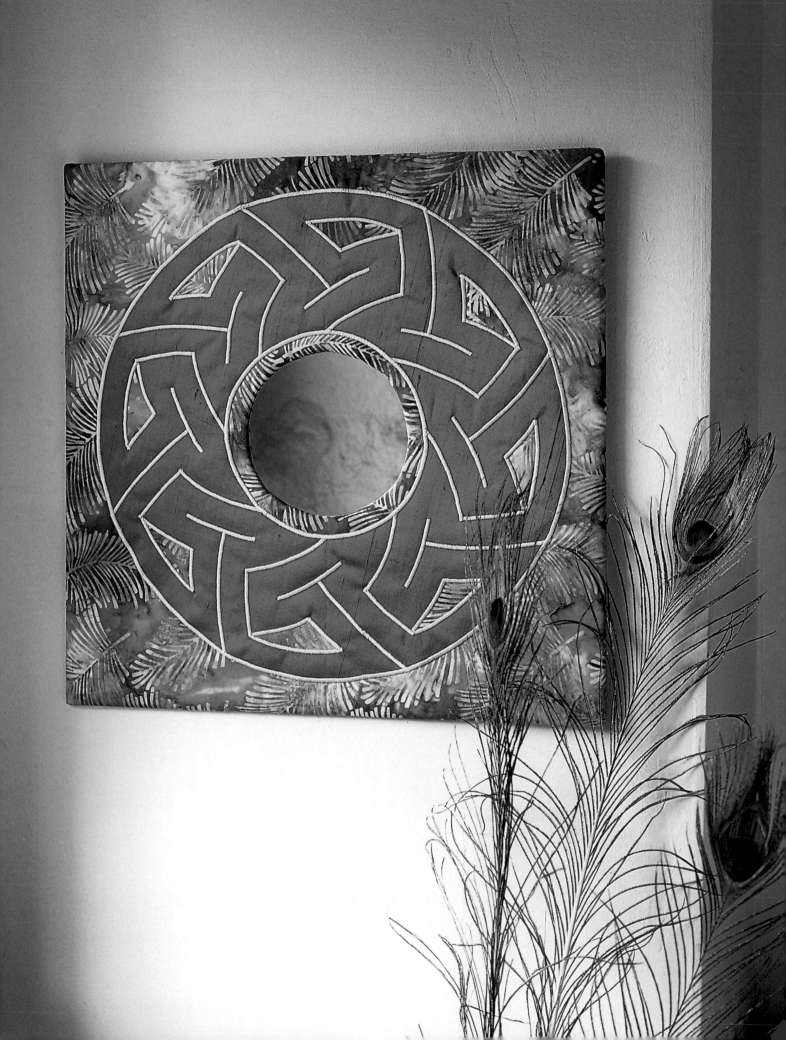

MIRROR FRAME

Make the most of a bright, modern print fabric, offset with the gleam of silk dupion, and create a dramatic mirror frame. The circular key pattern is created by the clever use of lines of machine satin stitch. I based the design on an ancient one formed from seven identical sections, simplifying and adapting it so it has eight sections instead and uses fewer lines.

Easiness Rating
Fairly Easy ☆
If you're confident with machine satin stitch

Techniques Used
Machine satin stitch
Using bonding web
Basic hand sewing

Finished Size of Mirror Frame
43cm (17in) square

MATERIALS

- Plain paper 41cm (16in) square, plus pencil, ruler, eraser and pencil crayon
- Bonding web 41cm (16in) square
- Plain silk dupion 41cm (16in) square
- Cotton print fabric to tone with the silk 48cm (19in) square
- Foundation paper (e.g. Stitch 'n' Tear or cartridge paper) 41cm (16in) square
- Cotton fabric to back the frame 48cm (19in) square
- Thick card, two 43cm (17in) squares
- Compressed wadding (batting) 43cm (17in) square
- Sewing thread to match the print fabric
- Large spool of machine-embroidery thread to contrast with the silk fabric
- Craft knife, stick glue and masking tape
- Square or circular mirror at least 18cm (7in) wide
- Two large curtain rings

Producing the Design

1 Fold the square of paper into quarters, then unfold. Lay one quarter of the paper over Fig 1 on page 66, matching the fold lines, and trace the lines of the design in pencil using a mixture of solid and dotted lines as on the diagram. Trace the design into the other three quarters of the paper to create a complete circular design (Fig 2).

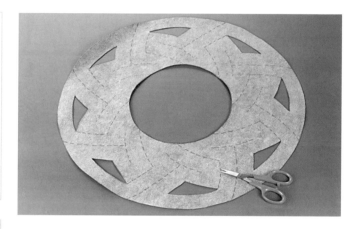

2 Lay the bonding web, paper side up, over the design and trace all the lines, again using a mixture of solid and dotted lines as indicated. Lay the bonding web on the wrong side of the dupion, web side down, and use a warm iron to fuse it in place. Cut the design out around the outer and inner circles and cut out the triangles marked by the solid lines.

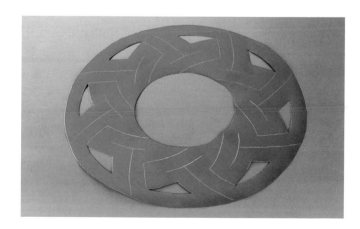

3 Lay the design, fabric side up, on a lightbox (or tape it to a bright window on a sunny day) so you can see the dotted lines clearly through the fabric, and use a pencil crayon to draw all the lines of the design on to the fabric.

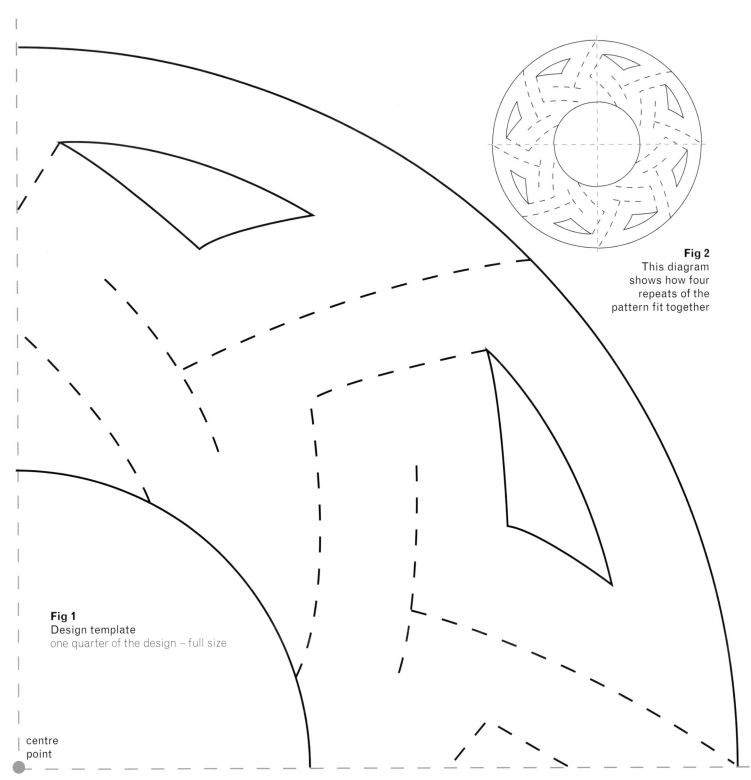

Fig 2
This diagram
shows how four
repeats of the
pattern fit together

Fig 1
Design template
one quarter of the design – full size

centre
point

Variation

*This simple design would also look
very effective as a cushion cover
using leftover curtain or upholstery
fabric as the print background.*

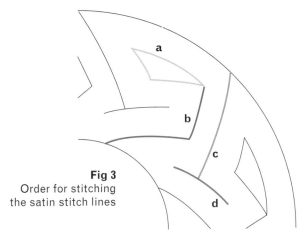

Fig 3
Order for stitching
the satin stitch lines

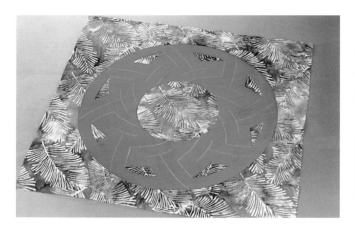

4 Fold the square of print fabric into quarters, press the folds and unfold. Peel the paper off the back of the circular motif and lay it, right side up, on the front of the print square, making sure that the circle is evenly aligned on the folds in the fabric. Carefully fuse the design into position.

5 Lay the square of foundation paper on a flat surface and cover it with the square of wadding (batting). Lay the decorated print square, right side up, on top of the wadding, positioning it so there is a 2.5cm (1in) border of fabric showing all around. Tack (baste) the three layers together.

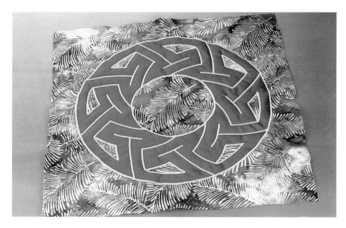

6 Thread your machine with the embroidery thread and set it up for a medium-width satin stitch (about 3.5). Follow the satin stitch instructions on page 63 to stitch a smooth line of satin stitch along the lines of the design. Stitch the lines in the sequence shown in Fig 3, beginning with each triangle (a) and the angled line going down from it (b). You are now left with eight curved T shapes. Stitch the stem of one T first (c), then its cross-bar (d). Repeat with the other T shapes. Finally, stitch round the inside and outside circles. Remove the tacking (basting) stitches and tear the foundation paper away from the back.

Making Up the Frame

7 Take the two 43cm (17in) squares of card and draw in the diagonals on each piece. In the exact centre of one, draw a circle with a 12.5cm (5in) diameter and cut it out with a craft knife.

8 Spread glue over one side of this piece of card. Lay the stitched design face down on a flat surface and lay the glued card, glue side down, on top so there is an even border of fabric all the way around (Fig 4).

Fig 4 Card stuck on to design

Fig 5 Fabric edges stuck down

Fig 6 Wadding (batting) cut away from centre

Fig 7 Fabric in centre cut away leaving turning allowance

9 Fold the corners of the fabric to the back of the card and glue them down, then fold the raw edges of fabric over the card and glue them (Fig 5). On the wadding (batting) only, cut out the central circle flush with the circular edge of the card (Fig 6). Cut away the central circle of fabric (Fig 7), leaving a turning allowance of 2.5cm (1in). Clip this allowance, cutting just short of the edge of the card, then glue the fabric over the card to neaten it (Fig 8).

Fig 8 Turning allowance clipped and stuck to card

Fig 9 Mirror stuck to second piece of card with masking tape

10 Glue the piece of plain backing fabric over the other square of card, folding the raw edges over to the side marked with the diagonals. Position the mirror in the centre using the diagonals as guides. Secure in place with strips of masking tape on the very edges, so the tape won't show under the frame (Fig 9).

11 Lay the two pieces of card wrong sides together and use sewing thread to slipstitch the edges together all round the outside of the square. On the back, stitch a curtain ring at each top corner for hanging.

CHRISTMAS TABLE RUNNER

Celebrate the festive season in style with a colourful table runner in Christmas fabrics. The simple Celtic key design is created in patchwork using basic strip-piecing, padded with a layer of wadding (batting) and finished off with tassels and Christmas charms. Choose three contrasting seasonal fabrics for this design to make the most of the strong pattern of the patchwork.

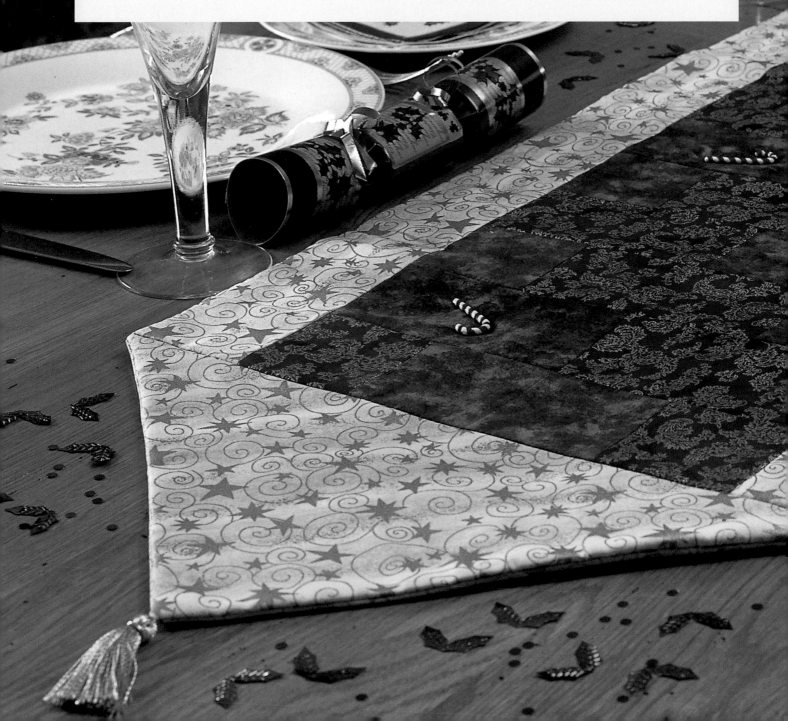

M A T E R I A L S

- Red and green Christmas-print cotton fabrics
 53 x 92cm (21 x 36in) rectangle of each
- Gold Christmas-print cotton fabric
 180cm (70in) long x at least 76cm (30in) wide
- Compressed 2oz wadding (batting) 41 x 180cm (16 x 70in)
- Sewing thread to tone with fabrics
- Nine Christmas charms and matching thread
- Two gold tassels, either home-made or ready-made

Piecing the Design

To make the patchwork work properly there are two separate sets of instructions for the cutting and piecing – one if working in metric and one for imperial.

1 *If working in metric:* From the rectangle of green fabric cut two strips 92 x 16cm and two strips 92 x 9.5cm. Do the same with the red fabric. From the gold fabric, cut one strip 180 x 41cm and set it aside. From the remaining fabric cut one 30cm square, and two 130 x 9.5cm strips.

1 *If working in imperial:* From the rectangle of green fabric cut two strips 36 x 6in and two strips 36 x 3½in. Do the same with the red fabric. From the gold fabric, cut one strip 70 x 16in and set it aside. From the remaining fabric cut one 12in square, and two 50 x 3½in strips.

2 If working in metric, take a 1.5cm seam allowance as you create the patchwork; if working in imperial, take a ½in seam allowance throughout. Join one wide strip of red fabric and one wide strip of green fabric to each other and press the seam open. From this composite strip, cut nine new strips (Fig 1) each measuring 9.5cm (3½in) wide – these are strips a.

3 Join a narrow strip of red fabric to each side of the other wide strip of green fabric and press seams open. From this composite strip, cut four new strips (Fig 2) each 9.5cm (3½in) wide – these are strips b.

4 Join a narrow strip of green fabric to each side of the other wide strip of red fabric and press seams open. From this composite strip, cut six new strips (Fig 3) each 9.5cm (3½in) wide – these are strips c.

Fig 1

Fig 2

Fig 3

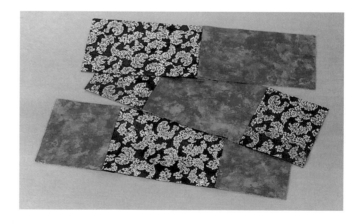

Variation

*A runner created in
white and silver or cream
and gold fabrics would
make a lovely top-table
decoration for a wedding.*

5 Lay the strips out on a flat surface in the order shown in Fig 4. For the sections marked a*, turn the strip round so the green fabric is at the bottom. Join the strips in the same order to create the key pattern shown in Fig 5. Press all seams open.

b a c a* c a b a* c a c a* b a c a* c a b

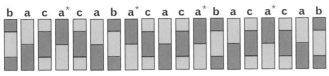

Fig 4

Fig 5

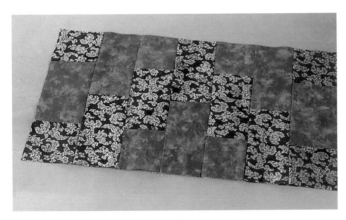

6 Add one of the narrow strips of gold fabric to each long side of the patchwork strip (Fig 6).

Fig 6

7 Cut the square of gold fabric in half diagonally to create two triangles. Add one triangle to each end of the patchwork (Fig 7), joining the long edge each time and pressing the seams towards the strips. If necessary, trim the triangles down slightly so that they make neat, even points. Trim the long edges of the patchwork.

Fig 7

Making Up the Runner

8 Use the patchwork shape as a pattern to cut one identical shape from gold fabric and one from wadding (batting). Lay the patchwork and gold fabric right sides together with the wadding on top, and pin or tack (baste) the layers together. Stitch a 1.5cm (½in) seam all around, leaving 15cm (6in) open for turning. Clip corners, trim the wadding down to the seam line and turn out. Slipstitch the opening closed. Press the edges lightly to set the seams.

9 Stitch a charm on to the runner in each of the positions shown in Fig 8. Finish the runner by stitching a gold tassel on to each end point (see page 83 for instructions on making tassels).

Fig 8

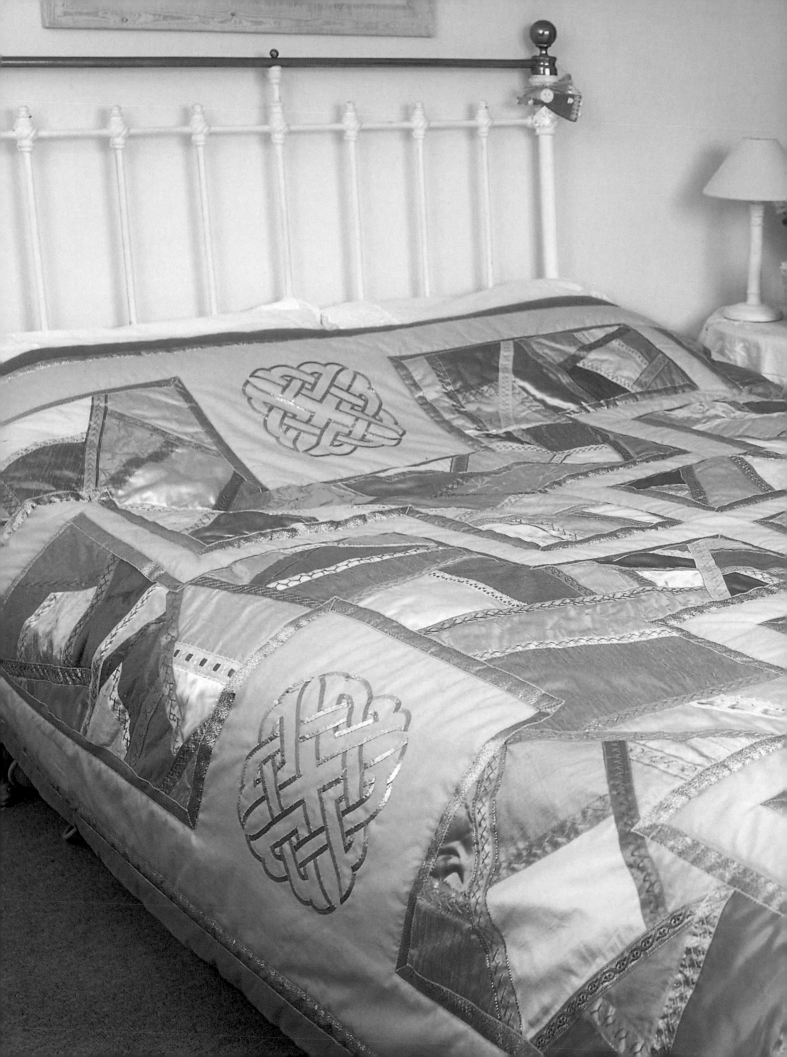

CRAZY BED QUILT

Gorgeous shades of cream, peach and café au lait are used on this sumptuous quilt, set off by gold ribbons and knotwork and embellished with hand embroidery. The design is a Celtic fret pattern, created from four identical interlocking shapes. The crazy patchwork is an adaptation of ordinary stained-glass patchwork using ribbons and strips of lace instead of bias binding. I've used slightly exotic fabrics such as silks, satins and brocades but you could use cotton fabrics. The embroidery adds a wonderful finishing touch but can be omitted.

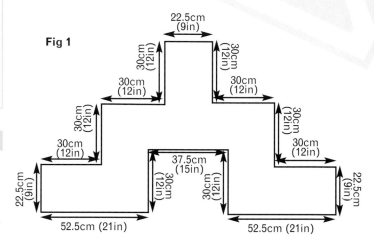

re-draw it as the pale lines of the crayon should mean that they don't show through any pale fabric patches. Once you're happy with the way you've divided up the four large shapes, cut patches from your patchwork fabrics and pin them in place on the foundation fabric shapes (Fig 3). You don't need to add seam allowances, but add a little extra round each edge if you're using fabrics that fray, such as silk.

Fig 1

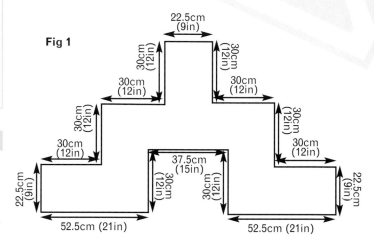

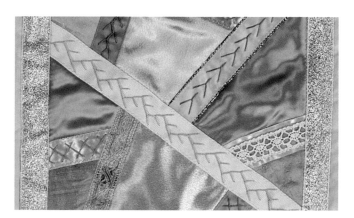

<div style="text-align:center">

Easiness Rating

Fairly Challenging ☆☆☆

The basic crazy stained-glass patchwork technique is easy to grasp but the quilt is large and has quite a lot of embellishment

Techniques Used

Crazy stained-glass patchwork
Using fusible bias binding
Basic machine sewing
Hand embroidery (optional)

Finished Size of Quilt

105cm (81in) square approximately

</div>

M A T E R I A L S

- Pencil, long ruler, set square and yellow/peach pencil crayon
- Rich cream cotton fabric or sheeting 105cm (81in) square
- White or cream foundation fabric 105cm (81in) square
- Dark peach cotton fabric or sheeting 115cm (85in) square
- 2oz polyester wadding (batting) 105cm (81in) square
- Large scraps of fabric in shades of cream, peach, gold and café au lait (about 5sq m/5sq yd in total, to have plenty of choice for patches)
- Assorted ribbons and strips of lace in different colours and widths to tone with fabrics (at least 40m/40yd in total, depending on size of fabric patches)
- Gold ribbon for edging 2.5cm (1in) wide x 36m (38yd)
- Fusible gold bias binding 6mm (¼in) wide x 13m (14yd)
- Dark cream sewing thread and other threads to match ribbons
- Hand-embroidery threads and needle (optional)
- Several large sheets of paper

Creating the Patchwork

This is another design where the metric and imperial measurements are slightly different so that you can work in whole numbers in whichever system you prefer. Keep to one or the other throughout the project so you don't get confused.

1 Tape together several sheets of paper to create a piece at least 90 x 150cm (35 x 60in). Use a long ruler and set square to draw out the shape in Fig 1, keeping to either metric or imperial measurements, and making sure that all corners are sharp right angles. Cut out the shape and use it as a template to cut four shapes from the white or cream foundation fabric. (If you use the rough layout of the quilt itself, see Fig 5 on page 75, you'll have enough fabric to cut all the shapes.)

2 Use the long ruler and coloured pencil crayon to draw lines on each piece of foundation fabric so that they're divided into random shapes, as shown in Fig 2. The exact size and shape of the patches doesn't matter; if you don't like the position of one line,

3 Once all the foundation pieces are covered, follow the instructions for stained-glass patchwork on page 107 to add strips of ribbon and lace to cover the joins between the patches (Fig 4). Don't add any ribbon round the edges of the main shapes at this stage. If you wish, you can decorate some or all of the strips of ribbon with hand embroidery at this point. Once all the foundation shapes are covered, use the paper template as a guide to trim them to shape.

4 Fold the rich cream fabric square into quarters, press the folds and unfold. Lay out on a flat surface, right side up. Lay the patchwork shapes on the front to create the design shown in Fig 5 – you'll find that if you leave a 'gutter' of about 7.5cm (3in) between the shapes the pattern will work properly and all the edges will align with each other. The design is asymmetrical, but the folds you've created will help you to align each shape in the same position on each quarter of the background fabric. Once they're all in the right positions, pin in place and use the pencil crayon and long ruler to trace round each shape, then unpin.

Fig 2

Fig 3

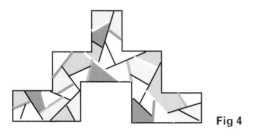

Fig 4

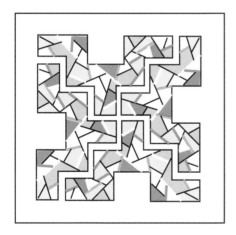

Fig 5

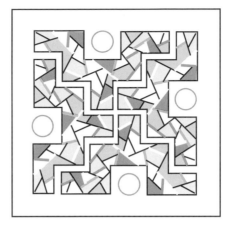

Fig 7

6 Follow the instructions on pages 32–33 to cover the lines of each knot with the gold fusible bias binding.

Finishing the Quilt

7 Pin the patchwork shapes in position again on the background fabric and stitch around the edges with a large zigzag in cream thread. Pin gold ribbon round the edge of each patchwork shape (Fig 8), mitring the corners and keeping the edges straight and the corners crisp. Stitch the inside edge of the ribbon only, and the mitres, with a small zigzag.

Adding the Knot Designs

5 Fold a 25cm (10in) square of plain paper in half, then trace the design in Fig 6 on page 76 twice, once into each half, so that you have a complete knot design. (Alternatively, photocopy the design twice and tape the halves together to create the complete knot.) Trace the design into the gap at the outside of each shape that you've drawn on to the background fabric (Fig 7), aligning the outside edge of the knot with the long edge of the fret shape, and making sure that there is an even border of fabric around the other three sides.

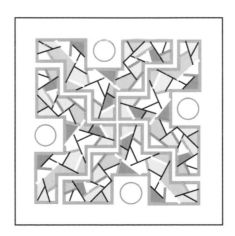

Fig 8

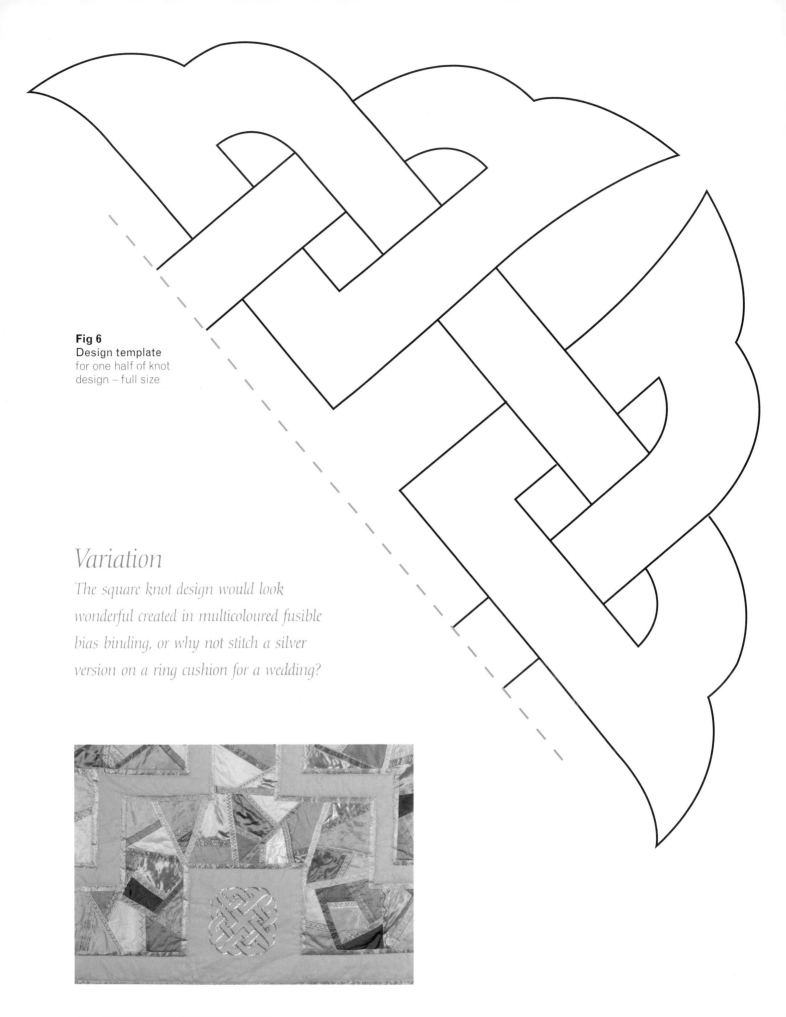

Fig 6
Design template
for one half of knot
design – full size

Variation

The square knot design would look
wonderful created in multicoloured fusible
bias binding, or why not stitch a silver
version on a ring cushion for a wedding?

8 Lay the dark peach backing fabric right side down on a flat surface and smooth it out. Lay the wadding (batting) on top, so there's an even border of fabric all around the edges. Cover the wadding (batting) with the quilt top, right side up, and use your preferred method to secure the layers of the quilt sandwich (see page 102). Use a small zigzag to stitch around the outside edge of each line of gold ribbon to finish the appliqué and secure the three layers together.

HANDY HINT

The background fabric is much easier to handle if you add the knots *before* you stitch the patchwork shapes in place.

9 Fold the edges of the peach fabric over to the front of the quilt and pin a line of gold ribbon over the raw edge (see picture above and Fig 9), making sure that you keep the lines of ribbon straight. Stitch the ribbon down each side to complete the binding.

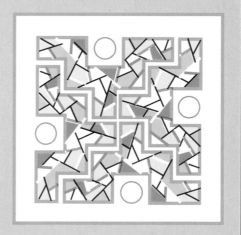

Fig 9

Variation

If a bed quilt seems too big a project, try creating small amounts of crazy stained-glass patchwork in different colours to decorate a box lid or the front of a cushion.

PLANTS AND ANIMALS

Not all the Celtic artists' designs are abstract patterns; they also enjoyed depicting biomorphic shapes such as plants, animals, fish, birds and people – both real and imagined. Some of the animals are depicted quite realistically and are instantly recognisable; others are wildly distorted. For some reason birds in particular are stretched and twisted into every conceivable shape. Other creatures, such as strange reptiles and sea-monsters, are pure fable. Plant shapes are often combined with knot or spiral designs to create decorative borders and corners. I've selected a few plant and animal designs and used them for a range of different projects, culminating in a wall hanging featuring a pair of spectacular peacocks.

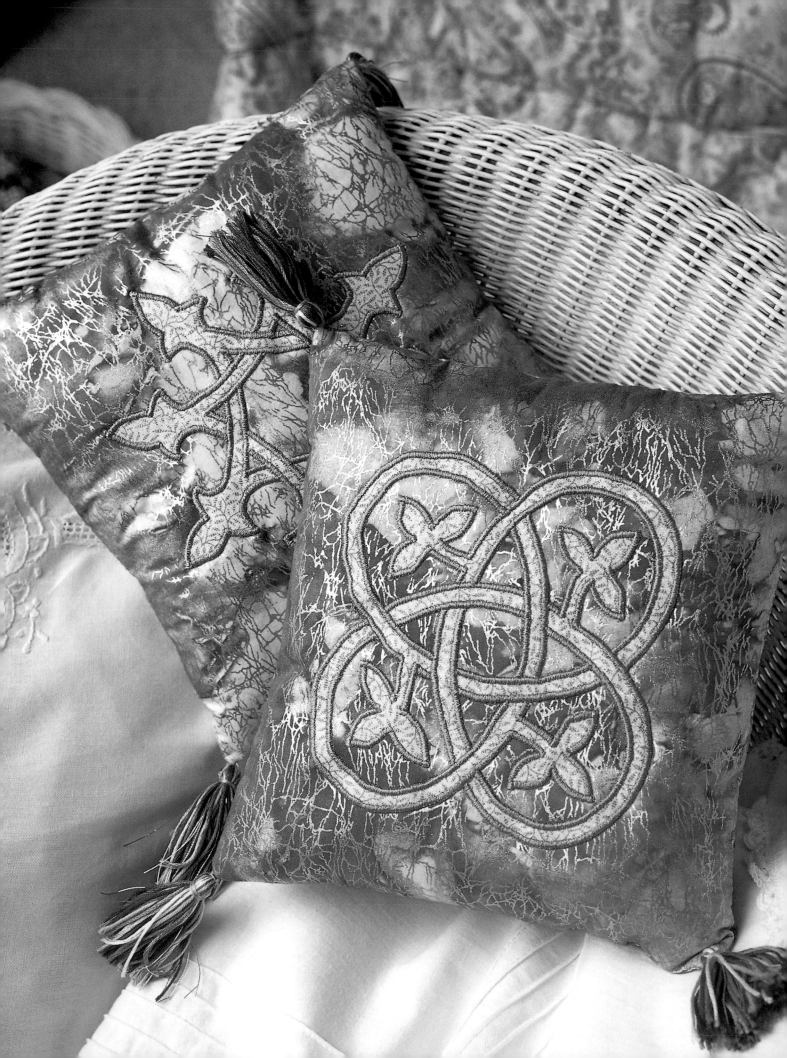

HERB SACHETS

Pop a little scented pillow into a clothes drawer or cupboard and you'll get a lovely waft of perfume every time you're choosing what to wear. Alternatively, scatter a few of these around your bedroom or bathroom, or make some for presents. Each little sachet is decorated with a stylized Celtic plant design, fused into place with bonding web and outlined with machine satin stitch. The corners are finished off with pretty, toning tassels.

Easiness Rating
Fairly easy ☆
The designs are quite small, the technique straightforward

Techniques Used
Simple machine appliqué
Using bonding web
Basic machine sewing
Making tassels (optional)

Finished Size of Sachet
20cm (8in) square

MATERIALS

For each sachet:
- Cotton print fabric, two 23cm (9in) squares
- Contrast cotton fabric 15cm (6in) square
- Bonding web 15cm (6in) square
- Foundation paper 15cm (6in) square
- Compressed wadding (batting) 20cm (8in) square
- Machine-embroidery thread to tone with your colour scheme
- Sewing thread to match the print fabric
- Pencil crayon to match the embroidery thread
- Synthetic stuffing and a small amount of pot-pourri
- Toning threads for tassels (optional)

Variation

You can use these designs in other ways as well as appliquéing them. Try enlarging the knots and using them as wholecloth designs on quilt blocks separated by sashing.

Producing the Design

1 Each design is produced in the same way. Choose which of the designs you want to use on your sachet (Fig 1 or Fig 2 on page 82) and lay the bonding web square, paper side up, over it. Trace the solid lines of the design in pencil, then fuse the bonding web to the back of the contrast fabric. Use small, sharp-pointed scissors to cut out the shape.

2 Lay one square of print fabric on a flat surface, right side up. Peel the backing paper off the design, lay it fabric side up in the centre of the square, and fuse into place. Use the pencil crayon to draw in the unders and overs on the design (marked as dotted lines on the main design). Now position the square of wadding (batting) centrally on the back of the fabric square and tack (baste) the layers together.

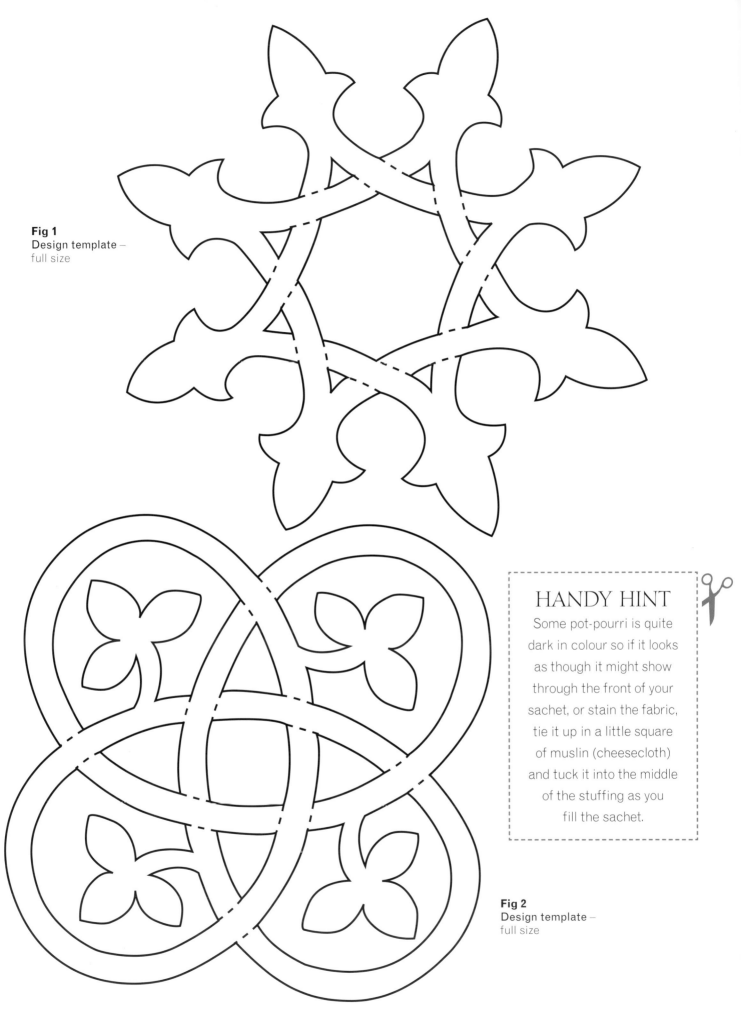

Fig 1
Design template –
full size

HANDY HINT
Some pot-pourri is quite
dark in colour so if it looks
as though it might show
through the front of your
sachet, or stain the fabric,
tie it up in a little square
of muslin (cheesecloth)
and tuck it into the middle
of the stuffing as you
fill the sachet.

Fig 2
Design template –
full size

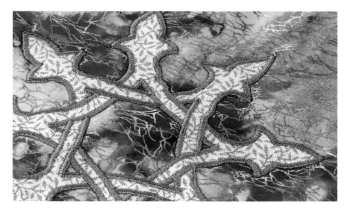

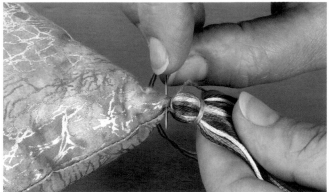

3 Slip the square of foundation paper under the wadding (batting) and follow the satin stitch instructions on page 63 to work an even, medium-width satin stitch round all the lines of the design. When all the stitching is complete, remove the tacking (basting) thread and tear the foundation paper away from the back of the work.

Making Up the Sachet

4 Lay the two squares of print fabric right sides together and stitch a 1.2cm (½in) seam all the way round the edges, leaving about 10cm (4in) open for turning. Clip the corners and trim the seams, then turn the sachet out to the right side and press the seams to set them, turning under the seam allowance of the opening as you press.

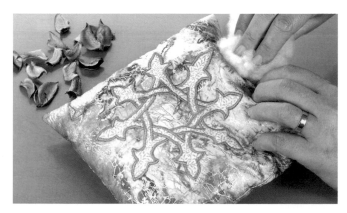

5 Use a mixture of stuffing and pot-pourri to fill the sachet fairly firmly. When it's full, use ladder stitch to close the opening (see page 101).

6 If you'd like to finish off the sachet with tassels, follow the instructions below to create four tassels and stitch one on to each corner.

Making Tassels

There are various ways of making tassels but this is one of the easiest. It makes two matching tassels at the same time, using mixed threads, though of course you can make the tassels from all the same thread.

1 Cut a piece of card at least twice as long as you want your finished tassels to be and wind a mixture of threads around it fairly thickly.

2 Thread a needle and slip it under the loops at one end. Knot the thread tightly and then do the same at the other end. Slip the loops off the card and cut across the centre.

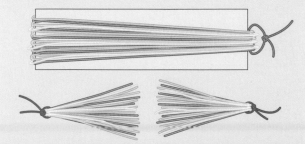

3 Wind a toning thread tightly around the neck of each tassel to create the tassel head and use a needle to stitch the end of this thread into the tassel several times to secure it. Trim the ends of the tassel neatly to the required length.

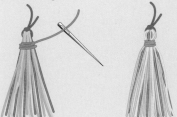

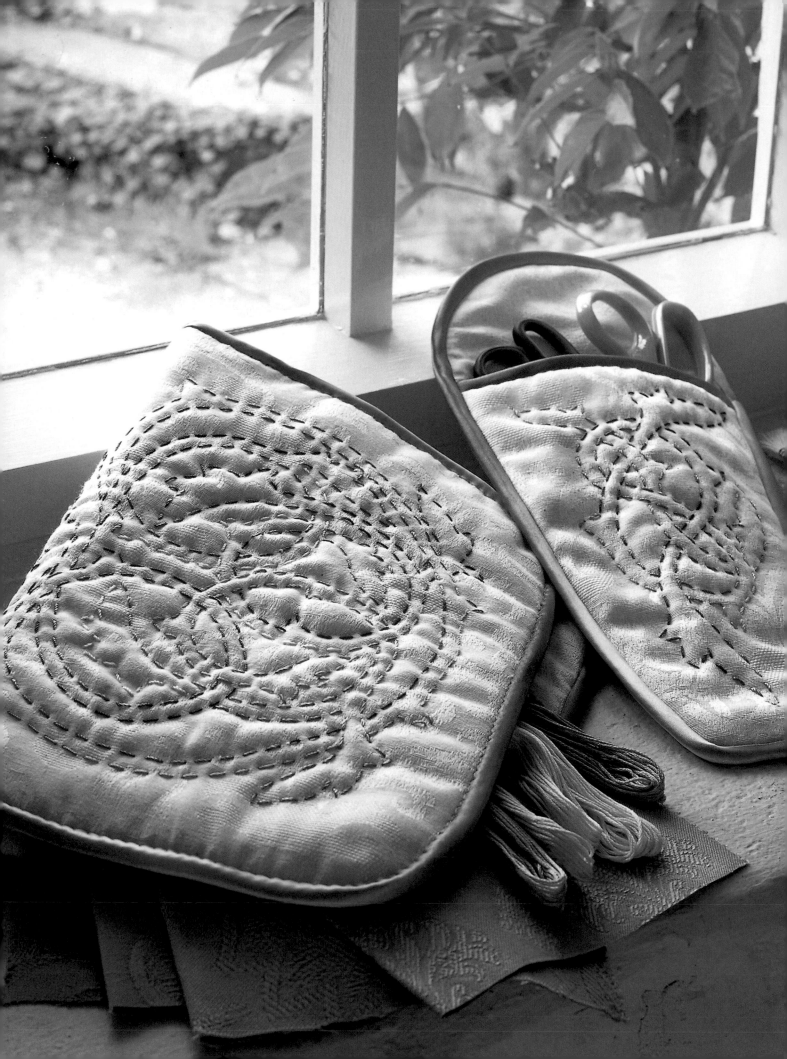

SCISSORS CASE AND SEWING CADDY

This padded case and caddy are ideal for taking stitching when travelling. The case is big enough for two pairs of scissors, while sewing and threads slip into the pockets of the caddy. The plant designs are stitched with a multicoloured thread which complements the bias binding, although you could use a plain binding.

Easiness Rating
Fairly Easy ☆
If you're a beginner, stitch the scissors case first before the more complex knots of the caddy

Techniques Used
Big-stitch quilting
Basic machine sewing
Attaching bias binding

Finished Sizes
Scissors case 16.5 x 25cm (6½ x 10in)
Sewing caddy 45 x 30cm (18 x 12in)

M A T E R I A L S

For the case and caddy:
- Multicoloured embroidery thread, e.g. coton perlé or coton à broder
- Sewing thread to match the fabric
- Embroidery needle with a large eye
- Pencil crayon in pale blue

For the scissors case:
- Cream brocade fabric, two rectangles 20 x 30cm (8 x 12in) and two rectangles 20 x 38cm (8 x 12in)
- Compressed 2oz wadding (batting), one rectangle 20 x 30cm (8 x 12in) and one rectangle 20 x 38cm (8 x 15in)
- Multicoloured bias binding 110cm (45in) x 2cm (¾in) wide when folded
- Button, bead or snap fastener closure (optional)

For the sewing caddy:
- Cream brocade fabric, two rectangles 45 x 30cm (18 x 12in) and four rectangles 25 x 30cm (10 x 12in)
- Compressed 2oz wadding (batting), one rectangle 45 x 30cm (18 x 12in) and two rectangles 25 x 30cm (10 x 12in)
- Multicoloured bias binding 225cm (90in) x 2cm (¾in) wide when folded

Producing the Scissors Case Design

1 Lay one of the smaller rectangles of cream fabric, right side up, over Fig 1 on page 86, so there is a roughly equal border of fabric all round. Use the pencil crayon to trace the design on to the fabric. If your fabric is very thick, use a lightbox or tape the design and fabric to a sunny window.

2 Measure the distance from the tip of the design to the bottom of the rectangle, then measure the same distance up from the bottom of the larger rectangle of fabric and put a pin in at that level to mark it. Trace the design on to the right side of the second rectangle, positioning it so that the tip of the design is on the pin mark and there is an equal border of fabric at the sides.

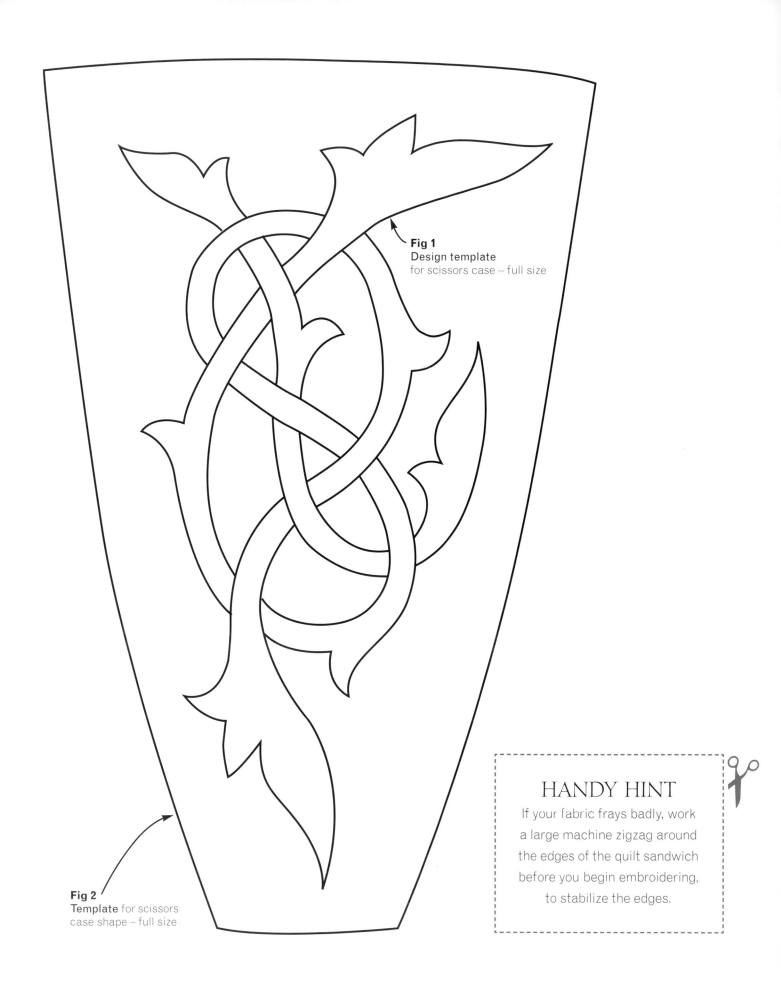

Fig 1
Design template
for scissors case – full size

Fig 2
Template for scissors
case shape – full size

HANDY HINT

If your fabric frays badly, work
a large machine zigzag around
the edges of the quilt sandwich
before you begin embroidering,
to stabilize the edges.

7 Back the smaller design with its backing fabric and use a strip of bias binding to bind the top edge (see page 109). Lay the larger design right side down, followed by its matching piece of fabric, right side up. Cover these with the smaller design, right side up, making sure the bottom edges and sides of all layers align. Bind all around the shape, adding a closure to the top flap if you wish.

3 Lay the smaller piece of wadding (batting) on a flat surface, lay the smaller marked rectangle, right side up, on top and tack (baste) the two layers together. Make a similar 'sandwich' with the larger piece of wadding (batting) and the larger design.

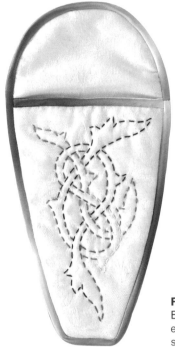

Fig 3
Binding the raw edges of the scissors case

4 Use the multicoloured thread to work big-stitch quilting (see page 104) around all the lines of the design. Quilt the design on the larger rectangle in the same way. When all the stitching is complete, remove the tacking (basting) threads.

Making Up the Scissors Case

5 Trace or photocopy the template for the case (Fig 2 on page 86) and cut out the shape. Lay the shape over the stitched design on the smaller rectangle, so the design is centred. Draw round the edges of the paper template in pencil crayon. Cut around the shape, leaving a 6mm (¼in) seam allowance all around the edge. Cut a matching shape from the smaller spare piece of cream fabric.

6 Lay the shaped fabric on the larger design so the quilted motifs align and use the pencil crayon to draw around the side and bottom of the fabric shape. At the top of the shape, continue the lines of the sides to create a half circle (see Fig 3 for shape). Cut round the marked line (seam allowances are already included), then cut a matching shape from the remaining spare piece of cream fabric.

Producing the Sewing Caddy Design

1 Fold one of the larger rectangles of cream fabric in half and press the fold lightly. Unfold and lay one half of the rectangle, right side up, over Fig 4 on page 88, so there is a roughly equal border of fabric all round. Use the pencil crayon to trace the design on to the fabric. Turn the fabric round and trace the design on to the second half in the same way (Fig 5 below). Now trace the design centrally on to two of the smaller rectangles of fabric.

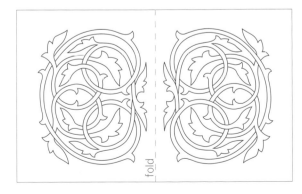

Fig 5
Caddy design traced on each side of the large cream rectangle

Fig 4
Design template
for sewing caddy – full size

2 Use the pieces of wadding (batting) to make quilt 'sandwiches' with the pieces as in step 3 of the scissors case on page 87. Use multicoloured thread and big-stitch quilting to stitch the designs, and then remove the tacking (basting) threads.

Making Up the Sewing Caddy

3 Round all the corners of the large rectangle, and the two outside corners of each smaller rectangle. Round the corners of the spare pieces of cream fabric to match, and pin these to the quilted designs, wrong sides together. Use the bias binding to bind the straight edges of each smaller rectangle.

4 Lay the large rectangle right side down on a flat surface and position the two smaller shapes on top, right sides up, overlapping the straight edges slightly so that the rounded corners of the shapes align. Bind all the way around the edge to finish the caddy (Fig 6).

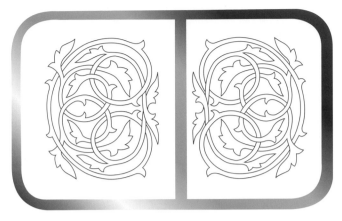

Fig 6
Binding around the edges of all three pieces of the sewing caddy

Variation

The large plant design would work well on the fronts of a waistcoat or a softly quilted jacket.

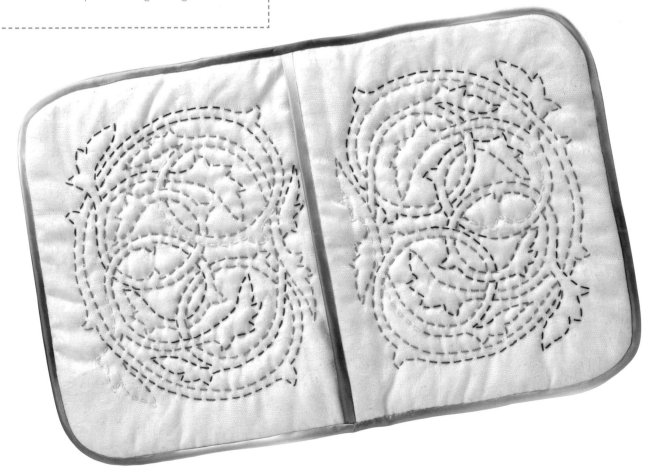

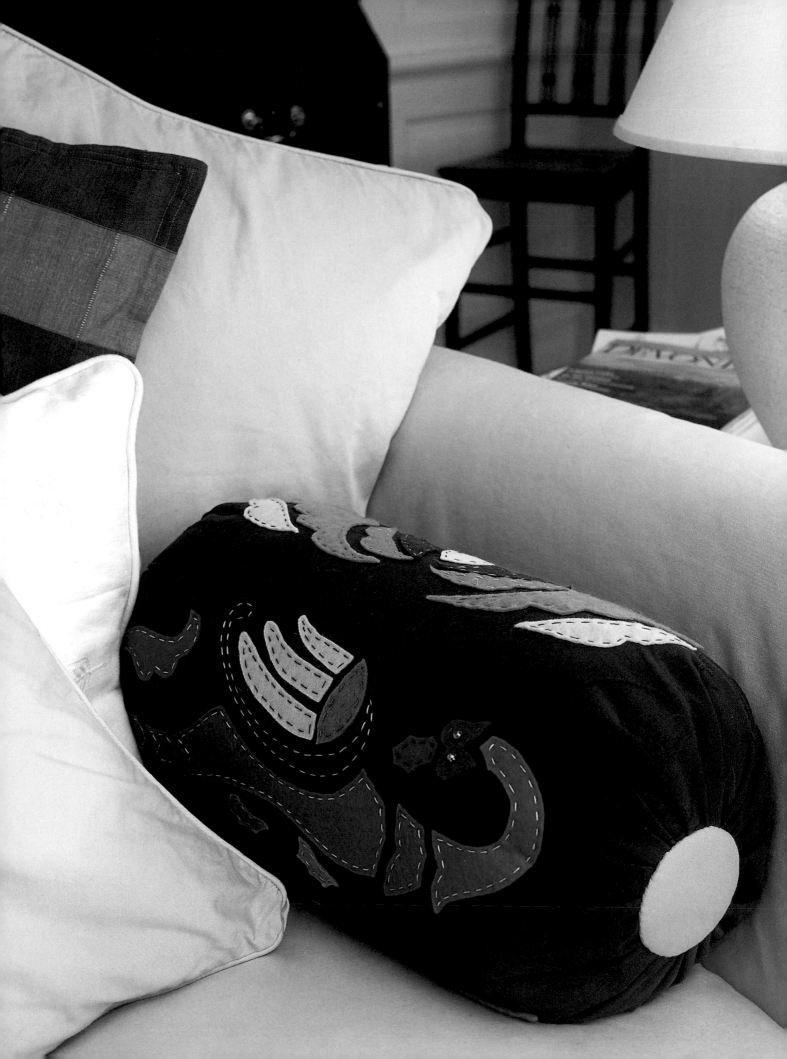

DRAGON BOLSTER

Various Celtic dragons and reptiles were the inspiration for this brightly coloured design, with the colours of the plant designs complementing the colours of the dragons. The technique is folk-art appliqué, a very simple form of applied work using felt patches attached with large running stitches. I've picked colours that contrast with the patches each time but if you prefer you could match the stitching to the felt shapes.

Easiness Rating
Medium ☆☆
The appliqué is easy but there are quite a few pieces to cut and stitch

Techniques Used
Folk-art appliqué
Basic machine stitching
Creating covered circles

Finished Size of Bolster
About 45cm (18in) long and 75cm (30in) in circumference

MATERIALS

- Thick blue brocade or damask fabric 70 x 82cm (28 x 32in)
- Large scraps of craft felt or kunin felt in lots of bright colours
- Cotons à broder in lots of different colours
- Firm cardboard, two circles 9cm (3½in) diameter
- Polyester wadding (batting), two circles 9cm (3½in) diameter
- Furnishing fabric to contrast with the blue fabric, two circles 13cm (5in) diameter
- Large sewing needle
- Sewing thread to match the blue fabric and the contrast fabric
- Strong thread (such as buttonhole thread) for gathering
- Pale pencil crayon
- Adhesive tape and stick glue
- Bolster roughly 45cm (18in) long and 75cm (30in) in circumference
- Four small, round beads for the dragons' eyes

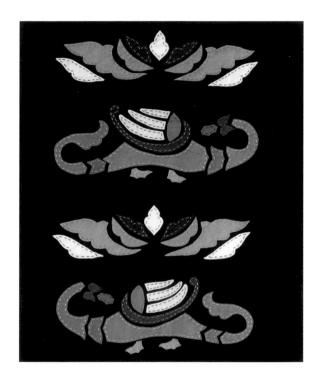

Producing the Design

1 Make two photocopies of Fig 1 on page 92, enlarging by 230% each time. Turn one of the photocopies over and trace the design through on to the other side of the paper so the dragon is reversed. Tape the two copies together to make a complete design, evenly spaced as in the picture of the stitched design, above right.

2 Lay the blue fabric right side up over the design so there's an even border of fabric down each side and a small border of fabric top and bottom. Pin the layers together. Use a lightbox or tape the design to a sunny window so you can see the lines through the fabric, and use a pencil crayon to trace all the lines of the design on to the blue fabric, then unpin.

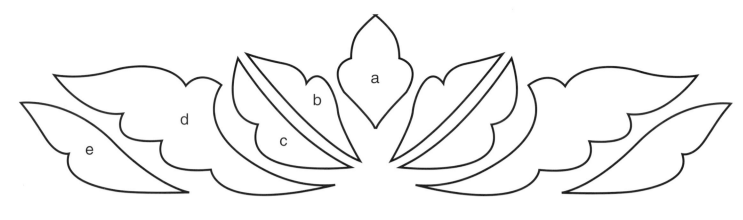

Fig 1
Dragon and plant motifs –
enlarge by 230%

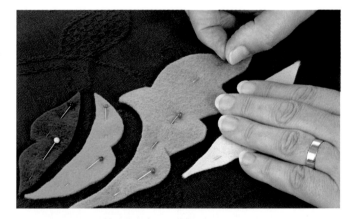

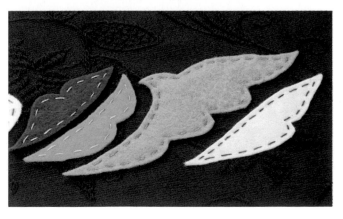

3 Cut up the parts of the pattern with letters on so you have one full-size template for each of the shapes that make up the design. Decide which colour felt you'd like to use for each part of the design and use the appropriate template to cut patches from the felt. You'll need to cut two shapes from each of the templates for the dragon (f–s), two shapes from template a, and four shapes from each of the templates b–e to give you enough for the whole design.

HANDY HINT

Felt doesn't have a wrong and right side so you don't have to worry about reversing the template for the mirror-image shapes of the dragon.

4 Pin the patches into position in the shapes marked on the blue fabric. Follow the instructions given on page 105 to appliqué the shapes into position, using different coton à broder colours. Once all the pieces are appliquéd, stitch two small beads on to each dragon's eye section.

Making Up the Bolster

5 Once all the different parts of the design are appliquéd, fold the blue fabric into a loose tube, right sides together, and stitch a 2.5cm (1in) seam along the join. Turn the design right side out and insert the bolster, making sure there's an even border of fabric on each side. Using strong thread and a large needle, run a gathering thread along one raw edge of the fabric, about 2.5cm (1in) in from the edge. Pull the gathers up tight over the end of the bolster (Fig 2), pushing any excess fabric into the hole at the centre of the gathers and securing the thread firmly so it won't unravel. Do the same with the other end of the bolster.

Fig 2

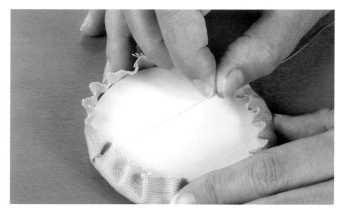

6 Follow the sequence of pictures below and right, first using stick glue to glue a circle of wadding (batting) to each circle of card. If the wadding doesn't seem very thick, use two circles on each piece. Run a gathering thread around the edge of one circle of contrast fabric, place a padded card circle, wadding side down, in the centre and draw the gathering thread up tight so the fabric is stretched evenly over the circle. Secure the end of the thread very firmly to create a giant padded button. Cover the second circle in the same way. Stitch one padded circle over each gathered end of the bolster.

Variation

Children would love the bright colours of this dragon so why not enlarge the templates and use them to decorate a toy bag or a kids' floor cushion?

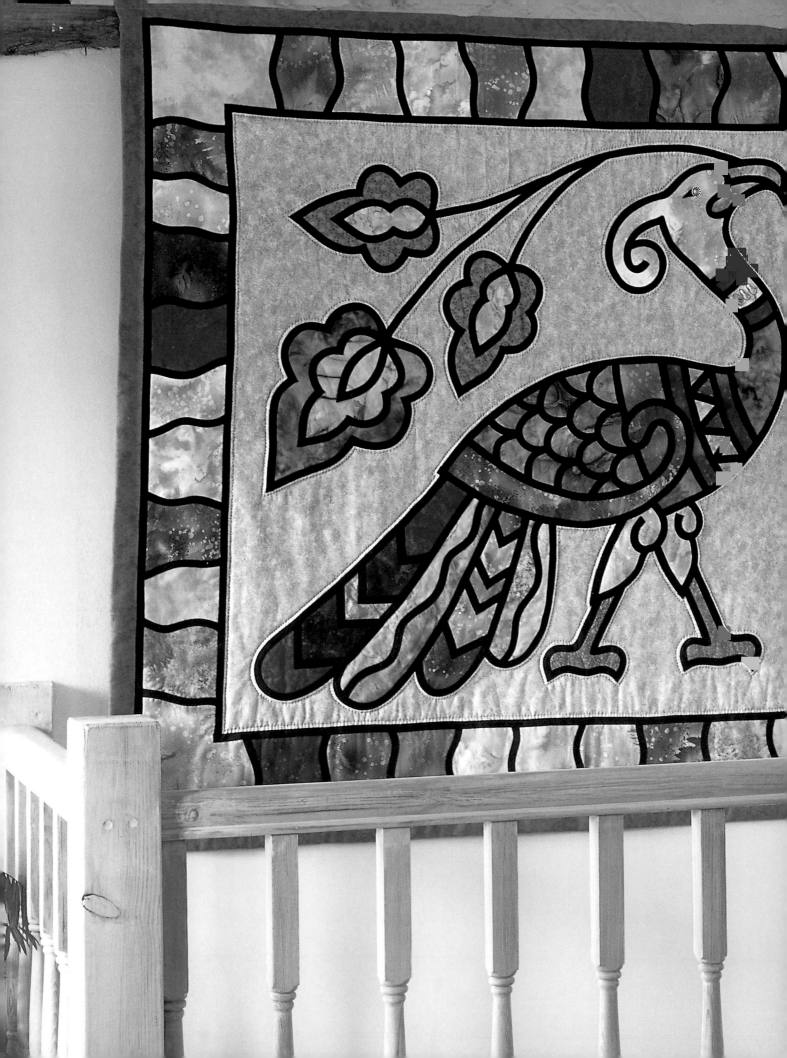

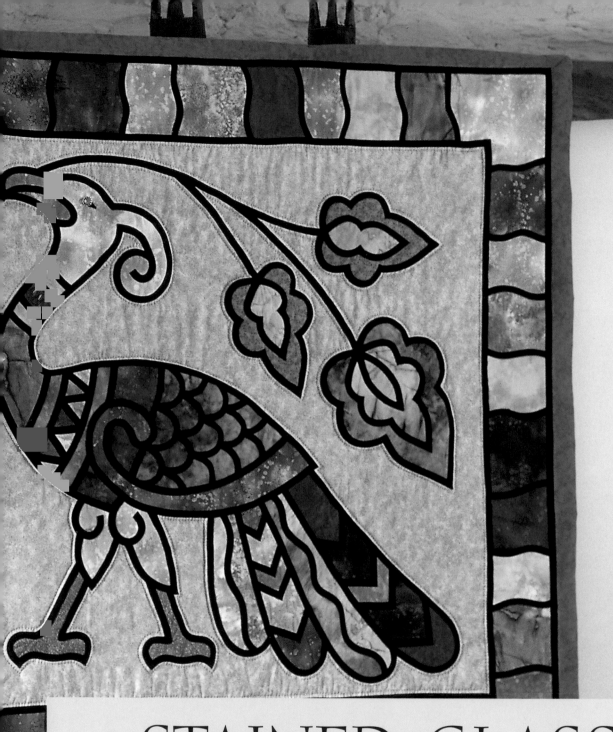

STAINED-GLASS PEACOCK HANGING

Two splendid peacocks strut across this wall hanging, flashing their feathers
and their jewelled collars. The design is created in stained-glass patchwork using
rich peacock colours – jade, royal blue, turquoise, lime green, pink and purple.
I've used mottled and hand-dyed fabrics to give the design extra richness
but you could use plains (solids) or small regular prints.

M A T E R I A L S

- Mauve background fabric 210 x 117cm (83 x 46in)
- Pink backing and binding fabric 228 x 135cm (90 x 53in)
- Compressed wadding (batting) 218 x 125cm (86 x 49in)
- Fat quarters or large scraps of cotton fabrics in bright peacock colours (at least 4sq m/4sq yd in total to have plenty of choice for the patches)
- Black bias binding 1.2cm (½in) wide, at least 65m (70yd)
- Black sewing thread and purple quilting thread
- Two decorative buttons or large beads for the eyes
- Fake jewels, sequins and beads and matching sewing threads (optional)
- Soft pencil, black felt-tip pen and long ruler
- Large sheets of paper
- Chalk marker

Producing the Peacock Design

1 Photocopy Fig 1 on page 97, enlarging it so each square measures 15cm (6in) – you'll probably need to do this in more than one stage. Alternatively, use the grid method (see page 100) to enlarge the design to the correct size. Go over the lines with black felt-tip pen to make them stronger. Fold the mauve fabric in half to make a square shape and press. Unfold it and use a long ruler and chalk marker to draw a line along the bottom end of the rectangle, 19cm (7½in) up from the raw edge (shown by the long dashed line in Fig 2).

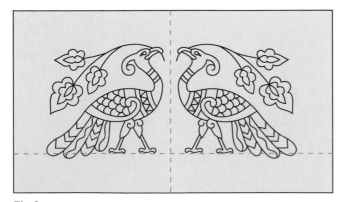

Fig 2

2 Lay the left-hand side of the fabric right side up over the peacock design, so that the beak of the peacock is 4cm (1½in) from the centre fold and the feet just touch the chalk line. Pin the design in place and trace the lines of the design on to the fabric in pencil. (You'll probably be able to see the lines through the fabric; if not, use a lightbox or a sunny window to help you.) Turn the paper design over and use the black felt-tip pen to trace the lines of the peacock on the back of the paper, then trace this reversed design on to the right-hand side of the mauve fabric (Fig 2).

3 Decide which fabric you'd like to use for which part of the design and follow the instructions for stained-glass patchwork on page 107 to cut patches from the bright fabrics. Put the patches in position on the background fabric (Fig 3) and secure them with a zigzag stitch. Follow the instructions for stained-glass patchwork to add the lines of binding, adding the lines in the sequence shown in Fig 4 a–g, so that you seal the raw ends of each line of bias binding as you go.

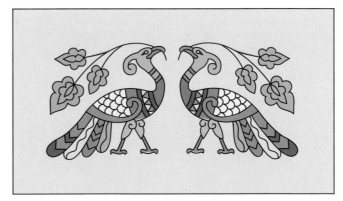

Fig 3

HANDY HINT

When you stitch the curl at the top of the leg
in Fig 4 step d, leave the outer edge of the
curve unstitched at this stage. This will enable
you to tuck the raw end of the tummy line
underneath the leg curl at step e, and you can
stitch the outer edge down then.

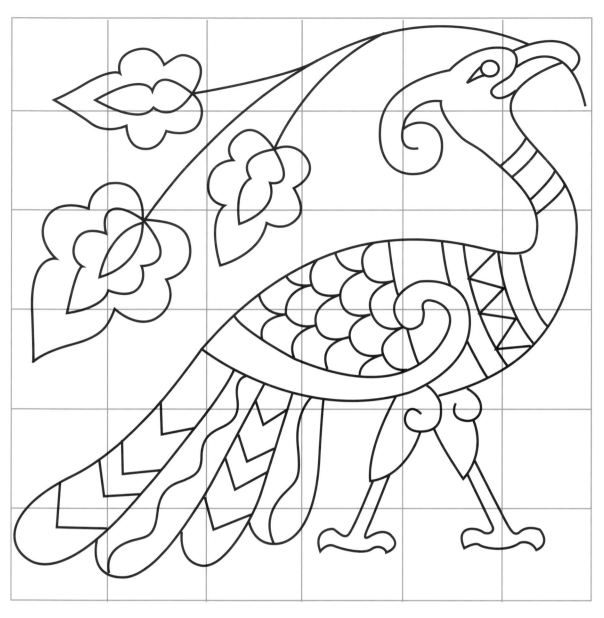

Fig 1
Peacock design – enlarge so each square measures 15cm (6in)

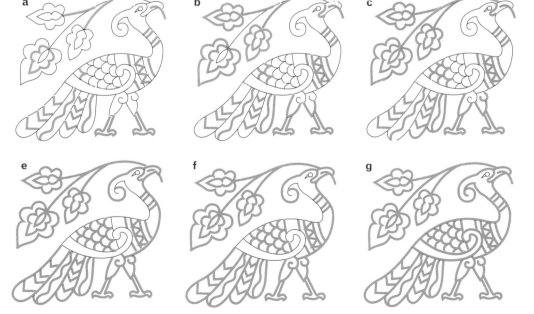

a b c d

e f g

Fig 4
Adding the lines of bias binding – at each stage add the line or lines shown in pink

Creating the Border

4 Once the peacock design is complete, use a chalk marker to draw a line 12.5cm (5in) in from each edge of the mauve backing fabric to create a frame shape for the border. Cover the border area with random patches of the bright fabrics, pinning them in place (Fig 5). Cover each corner with a right-angled patch to create a frame-shaped border. Stitch lines of bias binding down each join between the patches to secure them and to seal the raw edges (Fig 6). Add a line of bias binding round the inner edge of the border to seal the raw edges (Fig 7).

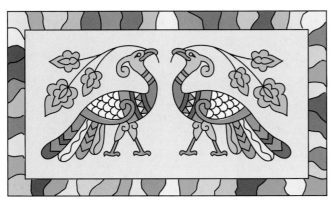

Fig 5

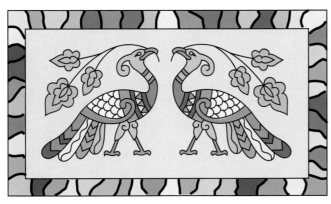

Fig 6

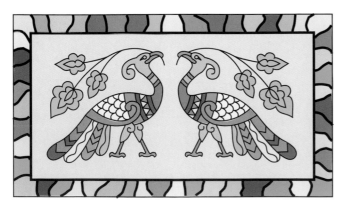

Fig 7

Making Up the Hanging

5 Lay the pink backing fabric right side down on a flat surface and smooth it out. Position the wadding (batting) on top, with an even border of fabric all the way around. Lay the peacock design on top of the wadding with an even frame of wadding round the design, then use your preferred method to secure the layers of the quilt sandwich (see page 102). Add a line of hand or machine quilting just outside each peacock shape and just inside the inner edge of the border (you can add more hand or machine stitching at this stage if you like).

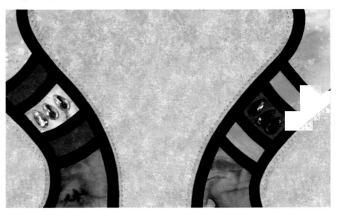

6 Stitch the jewels or beads into position to create the peacocks' eyes and collars and add a little embroidery to fill out the eye shape. If you'd like to embellish the quilt with fake jewels, sequins and so on, add them at this stage.

7 Fold the edges of the pink fabric over to the front of the quilt, mitring the corners and tucking the raw edges under the border. Make sure there is an even strip of pink fabric outside the border all the way round. Add a final line of bias binding round the outer edge of the border to neaten it and secure the layers together (see picture below). Add a casing on the back of the quilt for hanging it (see right).

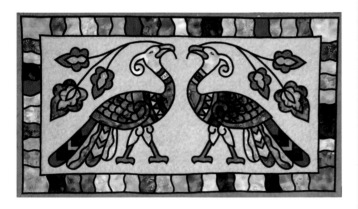

Adding a Casing

A casing is one of the easiest and most effective ways of hanging a large quilt or wall hanging as you can slip a pole through the casing, then mount the pole on large cup hooks or other rod hangers.

1 Measure the top edge of your quilt and add 2.5cm (1in). Cut a strip of fabric this length by 7–13cm (3–5in). (The larger and heavier your quilt, the deeper the width of your casing should be, so you can use a more substantial pole.) Turn under a small hem at the top and bottom of the casing, and a small double hem at each end, and machine stitch in place.

machine-stitched hem

2 Press the casing, then pin it in position at the top edge of the back of your quilt, just fractionally below the top of the binding. Slipstitch the two long edges in place, making sure that the stitches go into the wadding (batting): this will ensure that the quilt doesn't sag and that the stitches won't show on the quilt front.

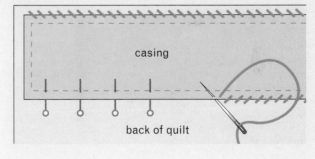

casing

back of quilt

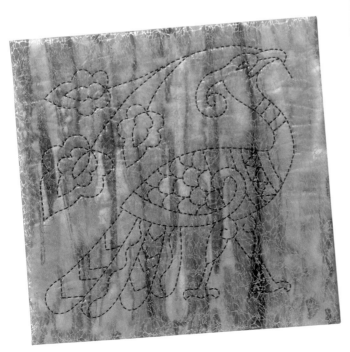

Variation

A single peacock motif at a smaller size works well as a picture, stitched on a multicoloured background.

TECHNIQUES

This section describes the techniques you will need to complete the projects in this book. As well as the specific techniques and stitches mentioned under particular projects, there are various other skills described here that you'll find useful.

Enlarging Designs

Most of the templates in this book are presented actual size but some are too large so you'll need to enlarge the designs.

Enlarging by photocopier Photocopiers are invaluable for relatively small enlargements (and for designs such as the cushions on page 20 where a quarter of the design is given full size and four repeats are needed). An enlargement percentage figure is given with the pattern where relevant.

Enlarging by grid For designs that need to be enlarged a great deal, such as the peacocks on page 94, it's best to use the grid method of enlargement. On a large piece of paper (use several stuck together if necessary), draw a grid containing the same arrangements of squares as the small design (Fig 1a) and at the size mentioned on the enlargement. Now copy the design lines within each square on to the squares of the larger grid, working one square at a time until the whole design is enlarged to the correct size (b).

Fig 1 Enlarging a design by the grid method

Marking Quilting Designs

There are many ways of marking quilting designs and some common ones are described here. If you're new to quilting, try a few out and see which works best for you. There are some occasions when certain marking methods won't be suitable (for instance, using water-soluble pen on a fabric that can't be wetted), or won't be easy (such as tracing through a thick, dark fabric). When you're planning a project, consider what will work best for the design and the fabrics you're using.

Marking pencils There are various types available. Some people like to use a silverpoint – a slender metal rod which transfers a light silvery-coloured line on to the surface of the fabric, like a fine pencil mark. This mark is usually invisible once the work is quilted. Ordinary pencil can be used for lines that are going to be hidden, such as those covered by satin stitch. Some people like to use a very fine pencil for marking wholecloth quilting designs too, but the pencil can still show on the finished work.

For quite complex designs I tend to use a pencil crayon in a colour similar to the quilting thread; the softness of the pencil means that the lines are more or less rubbed away as you work, and any light marks left will blend into the line of stitching. Alabaster pencils work in a similar way and are available in a variety of shades to suit different fabric colours.

Marking pens These fall into two main categories – water-soluble and air-fading. Water-soluble pens create a strong mark on the surface of the fabric, usually (but not always) in turquoise. Once the design is stitched, the fabric is sprayed or rinsed with water and the lines disappear. Air-fading pens also create a strong line, usually in purple, which acts as a guide for stitching; this line will fade after a day, sometimes more quickly, so it's not the technique to use on a long-term project!

Chalk markers Sometimes known as chaco-liners, these contain little wheels that produce a fine chalk line on the fabric. The chalk filling can be bought in different colours for different shades of fabric. As stitching is worked along the line it brushes away the chalk, but it's not the best technique for large designs as if you handle the work for a while, the lines you haven't worked will disappear along with the ones you have.

Transferring Quilting Designs

Whichever marking method you use, unless you're quilting relatively randomly you also need to decide how you physically transfer the correct design on to your fabric.

Templates Using templates cut from paper, card or special template plastic is one way to mark your design. Place the template on the surface of the fabric and trace round it with your chosen marking tool (Fig 2).

Tracing A design can be transferred by simply tracing it on to the fabric. Lay your fabric right side up over the drawn design, pin the two layers in place and trace the design on to the fabric surface in your chosen marking tool (Fig 3). If your fabric is pale, you can often see the design through it easily (to make it even easier, go over the lines of the design with black felt-tip pen to make them stronger). If you can't easily see through the fabric, use a lightbox, or tape the design to a sunny window.

Two methods which combine marking and transferring an accurate design on to fabric are dressmakers' carbon paper and transfer pens. With both of these the lines created can be quite strong so it's best to save them for techniques where the line will be covered by machine satin stitch or embroidery.

Dressmakers' carbon paper This is available in various colours. Place a sheet of it, carbon side down, on top of your fabric and cover it with the design you want to transfer, then draw round the lines of the design to transfer it to the fabric.

Transfer pencil This is used to draw your design in reverse on to paper. When you're happy with the design lay the paper, drawing side down, on to the surface of your fabric and press with an iron to transfer it.

Fig 2 Drawing around a template

Fig 3 Tracing a design on to fabric

Useful Stitches

As well as the individual stitches mentioned under various projects in the book, there are several other general sewing and embroidery stitches that you might find useful. See page 25 for instructions on working whipped running stitch, herringbone stitch and fern stitch and page 63 for machine satin stitch.

Running stitch

This is the most straightforward of the embroidery stitches. It is useful for creating the channels in Italian (corded) quilting (see page 108), and a variation of it is used for hand quilting (see page 103). To work running stitch, bring the needle out on the front of the work and take a series of small, even stitches along the stitching line (Fig 4). If you put the needle in and out of the fabric several times before pulling the thread through, it helps to keep stitches even and create a smooth line.

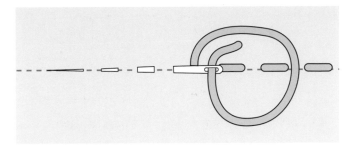

Fig 4 Running stitch

Backstitch

Backstitch is used to create a medium-weight stitched line. It's a good general embroidery stitch for single lines and works well for creating the channels in Italian (corded) quilting (see page 108). To work backstitch (Fig 5), bring the needle out at the beginning of the stitching line, then take a medium-length straight stitch and bring the needle out slightly further along the stitching line. Insert the needle at the end of the first stitch (a) and bring it out slightly further still along the stitching line (b). Continue in the same way to create a line of joined stitches.

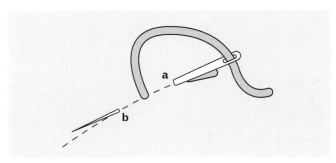

Fig 5 Backstitch

Ladder stitch

This is a very useful stitch for closing gaps in stuffed items such as pincushions and herb cushions as it is generally worked between two folded edges. Take straight stitches into the folded fabric, stitching into each edge in turn (Fig 6a). After a few stitches, pull the thread taut to draw up the stitches and close the gap (b).

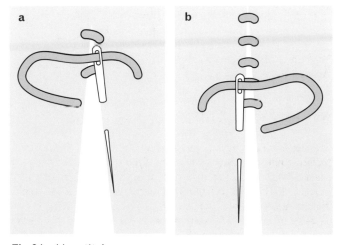

Fig 6 Ladder stitch

Slipstitch

This is a versatile stitch which can be used for hand appliqué and for tasks such as catching down bindings and casings. Take the needle into the background fabric, as close to the top fabric as possible, then bring it out at a slant so that it emerges just on the turned edge of the top fabric (Fig 7a). As you pull the stitches taut they will virtually disappear under the top fabric (b).

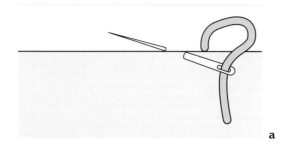

a

b

Fig 7 Slipstitch

Preparing Designs for Quilting

Quilting involves working on several layers of fabric simultaneously but fabrics tend to move in relation to each other as you work (especially on large projects) and this can cause puckers in the finished project. To prevent this problem, it's best to stabilize the layers (or 'quilt sandwich') in some way so that they stay still as you work. There are various ways of doing this and the one you use will depend mostly on your personal preference, and to a lesser extent on the size of the project, the technique you're using and the fabrics and wadding (batting) you're working with.

Tacking (basting) the layers The traditional way of stabilizing a quilt sandwich is by tacking the layers together. Lay the backing fabric right side down on a flat surface and smooth it out. Lay the wadding (batting) on top, then cover this with the quilt top or marked design, right side up. Work a grid of horizontal and vertical lines of tacking (basting) stitches across the sandwich at even intervals (Fig 8), making the lines about 15cm (6in) apart for large projects, slightly closer together for smaller or more intricate projects.

Tagging the layers Tack guns are a relatively modern development that shoot small plastic tags through the layers of the sandwich (Fig 9), and can be useful and time-saving for large projects. Once the quilting is complete, cut

through the stems of the tags to remove them. It's a good idea to make up a small square of the fabrics you'll be using and try the gun out on that first as sometimes the tacks can leave little holes on fine fabrics. It's also worth practising to ensure that each tack goes all the way through the sandwich and doesn't get stuck in the wadding (batting).

Safety pinning the layers A simple and speedy way of stabilizing large quilting projects is to use safety pins at regular intervals across the sandwich (Fig 10). A slight disadvantage of this method is that thread can sometimes get caught around the pins.

Pinning the layers If you're stitching a very small project, a few ordinary dressmakers' pins will often be enough to hold the layers together.

Gluing the layers This is another modern development in quilting as it's now possible to buy a special light spray glue which holds the layers together without making them sticky. It can be used for both hand and machine quilting. Always spray the wadding (batting) rather than the fabric and carefully unroll the quilt top across the wadding, smoothing it out as you go (Fig 11). Add the backing to the other side of the wadding in the same way.

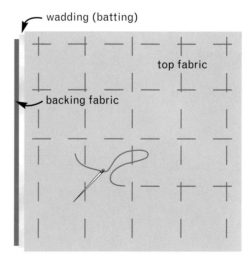

wadding (batting)

top fabric

backing fabric

Fig 8 Securing layers with a grid of tacking (basting)

Fig 9 Securing layers with tags

Fig 10 Securing layers with safety pins

wadding (batting)

quilt top folded back

Fig 11 Securing layers with glue

semicircular bars snapped
over tubular frame to
secure fabric

Fig 12 Securing layers with a frame

Securing in a frame Some people like to work with their quilting in a frame (see page 8). One way of combining the jobs of stabilizing and stretching the fabric simultaneously is to use a snap-on frame. Here, the layers of the sandwich are laid over the lower part of the frame, then pulled taut as the covers of the frame arms are snapped on (Fig 12).

Hand Quilting

Hand quilting is a straightforward technique of working tiny running stitches along the lines of a design. The stitching is worked on a quilt 'sandwich' (see page 100 and the previous section for how to mark and prepare designs for quilting), and draws the layers together to create a puffed texture. The complexity of the finished effect depends on the complexity of the marked design. Hand quilting is best worked in specialized quilting thread as this is stronger than normal sewing thread and is robust enough to withstand being pulled through the fabric numerous times without snapping or tangling. It's also possible to do hand quilting using fine silk threads and some metallic threads.

Thread your needle with a length of quilting thread and tie a knot in the end. Bring the needle out on the front of the work, pulling gently until the knot pops through the fabric and hides itself in the wadding (batting). Working with a rocking motion, take the needle in and out of the fabric several times along the stitching line (Fig 13a), then pull the thread through to create a row of small, even running stitches (b). The number of stitches per centimetre or inch isn't as important as making them even in length; uneven stitches create a rather untidy appearance. When you've finished the line of stitching, or need a new length of thread, make a knot in the thread just beyond your last stitch (c) and pull it through the fabric so that it too is hidden in the wadding (batting).

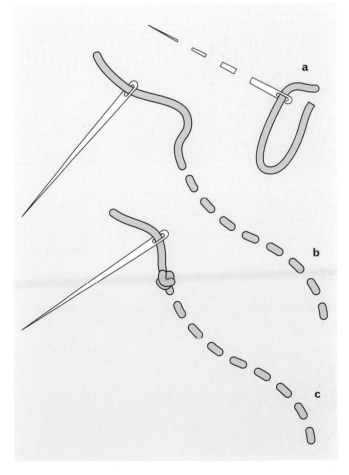

Fig 13 Hand quilting

Machine Quilting

There are many ways in which quilting can be done by machine and the method used will depend on the finished effect you're looking for. As with hand quilting, there are various ways to mark and create the quilt 'sandwich' (see page 102). If you're doing a fairly large amount of machine quilting with straight or decorative stitches, you may find it useful to invest in a walking foot for your machine.

The simplest kind of machine quilting consists of lines of straight machine stitching; these can be worked in a regular design (Fig 14a) or an irregular one (b). If your machine does fancy stitches, you can use these in various ways to create lines, little patches or shapes on the quilt sandwich (c). Some of these stitches can also be used to appliqué cord or decorative threads on to the fabric, quilting and embellishing at the same time (d).

Fig 14 Examples of machine quilting

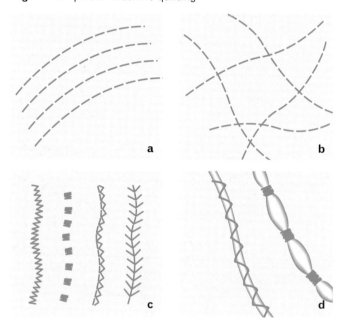

Free machine quilting involves using your hands to guide the movement of the fabric sandwich under the machine foot, instead of relying on the feed dogs (the little teeth in the middle of the needle plate) to move it. To do this kind of quilting, drop the feed dogs on your machine (your instruction manual will tell you how to do this), and fit an embroidery foot on your machine. You can then move the fabric carefully under the foot, guiding the needle where you want it to go. You can use this technique to create random patterns, sometimes called vermicelli (e), or to guide the machine round a more definite pattern (f).

Sashiko Stitching/ Big-Stitch Quilting

Sashiko is a Japanese technique which is a combination of quilting and embroidery. Unlike ordinary hand quilting, in which the stitches are almost invisible, in sashiko the stitches are large and create a decorative effect on the front of the work as well as doing the task of quilting a design into the layers. The stitches are often worked in a colour that contrasts with the background fabric. One particularly characteristic colour scheme is white stitching on dark blue indigo-dyed fabric. Sashiko is sometimes worked on two layers of fabric without wadding (batting) between, or with a thin layer of flat silk wadding between the fabrics, but the stitching works well on ordinary quilt 'sandwiches' as well.

Traditionally, sashiko is worked in simple repeat geometric patterns, often several different patterns in the same project. When a similar stitch is used for quilting other designs, or is worked randomly, it's often known simply as big-stitch quilting. Kantha stitching, an Indian technique, is similar and is often worked densely in bright colours over pale fabric. You can buy special sashiko thread in white and a few other colours but it's also possible to work this quilting very effectively using coton à broder, fine coton perlé and some of the more substantial silk threads. It looks particularly striking in variegated thread.

To work this kind of quilting, take quite long, even running stitches along the line of the design (Fig 15a), making each stitch roughly twice as long on the front of the work as it is on the back. Take several stitches on the needle at the same time as this will make the stitches more even and keep the lines of stitching accurate. At points and corners, you can either work the stitches so there's a small gap at the angle (b), or so that the two meet exactly at the angle (c). Try not to mix the two in the same project or the design will look uneven. When lines cross, work the stitches so there's a gap between stitches where the crossing occurs (d). If you work one stitch over another (e) the line will appear too dense at that point.

Fig 15 Sashiko quilting stitches

Folk-Art Appliqué

This technique combines simple appliqué and embroidery. The patches are secured to the background with lines of large running stitches which become part of the decorative effect – especially if worked in a contrasting colour. Because this type of appliqué doesn't neaten the edges of the patches, it's best for fabrics that don't fray (e.g., felt and bonded fabrics). It also works well on folksy, country-style designs in which a little bit of fraying doesn't matter; in these cases, you can minimize fraying by cutting out the patches with pinking shears and/or fusing the patches in place with bonding web before you start the appliqué.

If you'd like to use conventional fabrics for this technique but definitely don't want them to fray, make each patch up with a lining. Cut your patch with a 6mm (1/4in) seam allowance all round and cut a matching patch from a lightweight fabric such as lawn or even tulle. Stitch the two patches right sides together all round the seam line (Fig 16a), then clip any curves and trim any corners. Using sharp-pointed scissors, carefully cut a slit in the backing fabric only (b), then turn the shape out, press it and proceed with the folk-art appliqué as usual.

The appliqué itself is very simple: prepare each patch in your chosen way and position it on the background fabric. Work a line of quite large, even running stitches in a contrasting thread, a little way inside the edge of the patch (c) – the exact distance will depend on the size and complexity of your patches. The technique for the running stitches is similar to that for sashiko stitching (see opposite). Use a relatively thick thread such as coton à broder, fine coton perlé or a substantial silk thread, so the running stitches create part of the design. An alternative way to achieve a folksy look is by edging the shapes with blanket stitch (d).

Fig 16 Stages of folk-art appliqué

Machine Satin Stitch

This can be worked either as a method of simple embroidery or, if you work on a quilt sandwich, as a way of combining decoration with quilting. The close stitching has a tendency to distort the surface fabric so always use a tear-away foundation paper under the work to help prevent the distortion. It's possible to buy foundation paper under names such as Stitch 'n' Tear, but you can use ordinary cartridge paper (this blunts the needle slightly more quickly but works perfectly well).

Set the stitch length on your sewing machine to the position marked for satin stitch (indicated by a series of straight lines close together). If your machine doesn't do a specific satin stitch, set the stitch length as small as you can without the stitches becoming choked up on each other. Set the width to about 3mm and experiment on spare fabric, adjusting if necessary to make it narrower or wider. If possible, match bobbin thread to top thread to make the stitch look as neat as possible. If using a metallic thread, you may get a better, smoother stitch if you use a cotton thread in the bobbin that matches the colour of the metallic thread in the top. If your bobbin case has a little hole in the end of the arm, thread the bobbin thread through the hole before you load the bobbin case into the machine as this also helps to make the stitching as smooth as possible. See page 63 for diagrams and instructions on working machine satin stitch.

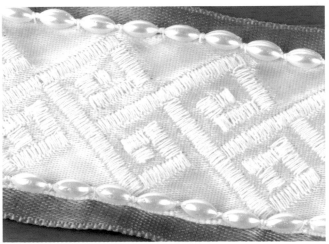

Piecing

Piecing, or patchwork, can be done by hand or machine but whichever method you choose, accuracy in cutting and stitching the patches is the key to success. Cut your patches to shape carefully, using either templates or a rotary cutter, ruler and mat. If your templates don't include seam allowances, add these as you cut the fabric patches (Fig 17a). The template will often indicate which way you should cut the patch in relation to the grain of the fabric; if the patch is square or rectangular, cut the patches so that the straight edges align with the lengthways and widthways grains. Detailed instructions on complex patchwork patterns are not needed for the projects in this book, only the basic ways of doing hand and machine piecing, as follows.

Hand piecing If you're going to be stitching by hand, use a pencil to mark the exact size of the finished patch on the back of the fabric shape (b), then put the patches right sides together, aligning the pencil lines, and pin or tack (baste) if you prefer. Using a small running stitch, stitch along the marked lines, making sure that the thread is secured strongly at the beginning and end of the line (c). If you wish, you can leave the stitching open by 6mm (¼in) at each end of the seam line.

Machine piecing If you're stitching by machine, practise doing an accurate 6mm (¼in) seam on your machine. (You may find it helpful to use the markings on your needle plate, or stick a piece of masking tape in the right position on the plate.) Pin the patches right sides together, and stitch a seam from one end to the other, keeping the line of stitching straight and accurate (d).

Once you've stitched a seam, by hand or machine, press the seam allowances to the darker side or open, depending on personal preference or on the precise project.

Fig 17 Piecing

fabric

template

a

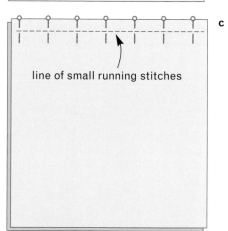

pencil line
marked on patch

b

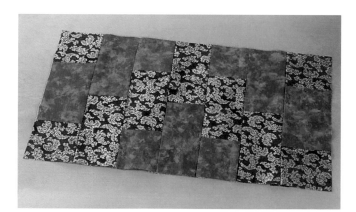

line of small running stitches

c

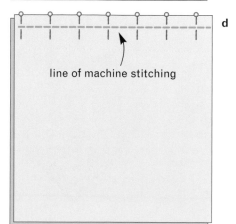

line of machine stitching

d

Stained-Glass Patchwork

Although this technique is called stained-glass patchwork, it's really a method of appliqué and is a very quick way of creating a striking design. First of all, draw your design full-size and trace it on to a thin layer of foundation fabric (sheeting or calico/muslin). Cut up the drawing to make templates and use these to cut patches from your chosen fabrics. You don't need to add any seam allowances as you're not actually piecing but you can add an extra 1mm (scant ⅛in) around the edges if you like. Pin the patches in place on the foundation fabric (Fig 18a) – you can tack (baste) if you like but it's not usually necessary. If it's a very large piece of work, you may find it useful to run a line of machine zigzag along the joins of the patches to hold them in place so that you don't have too many pins.

Fig 18 Stained-glass patchwork

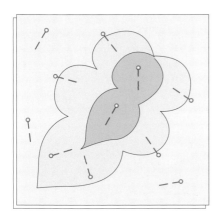

a

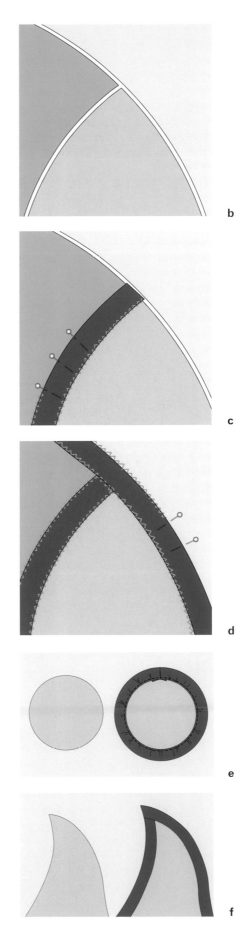

b

c

d

e

f

Now it's time to begin adding the bias binding. All the lines of the design are covered with binding, which seals the raw edges of the fabrics. Start with any lines that go into other lines to create T-junctions (b); if you do these first, the raw end of the first line of bias binding will be covered by the subsequent line, and so on. Where the lines of bias binding go off the edge of the design, you don't need to neaten the raw ends as they will be sealed in when the edges are neatened. Ease each line of bias binding around the curves of the design and pin. Stitch down each edge of each bias binding line with a small machine zigzag or hand slipstitch in matching thread (c), then carry on adding lines to cover the ends of the first lengths of binding (d).

If you need quite a tight curve in the bias binding, press the binding into a curve with a steam iron, which loosens the fibres. If the curve still isn't tight enough, run a gathering thread along the inside edge of the curve and pull it up slightly. If you find you can't hide the raw ends of a length of binding under another line of binding, for instance round a circle, fold the ends under themselves and butt them up (e). At corners and points, make a neat pleat in the bias binding to create a crisp shape (f).

Crazy stained-glass patchwork, as used in the quilt on page 72, is a variation of this technique, where strips of different ribbons, tapes, lace and braid are used to cover the joins between patches; these can be further embellished with hand embroidery and beading if you wish.

Italian (Corded) Quilting

This quilting creates a design consisting of padded channels and so is ideal for the elaborate knotwork designs of Celtic art. The design needs to be stitched on to layers of fabric so there is space between the layers for threading. The channels can be created using any straight line of stitching, such as running stitch, backstitch, stem stitch or straight machine stitching. If you use a translucent fabric for the front fabric of the work, you can thread the channels with coloured wool and create a kind of shadow-work effect.

Once the channels are stitched (Fig 19a) they are padded from the back of the stitching. Use small, sharp-pointed scissors to cut a very small slit in each end of each channel (b), making sure that you cut *only* through the backing fabric. Use a bodkin or large tapestry needle threaded with one or two lengths of wool (yarn) and take it along each channel; when you come to the end of a channel, bring the bodkin back up to the surface (c) and then down into the next channel of the design. When you reach a point or corner, bring the bodkin out at the back of the work again and then reinsert it, leaving a small loop of cord on the back to ensure the cord isn't pulled too tight (d).

Fig 19 Italian (corded) quilting

c

a

b

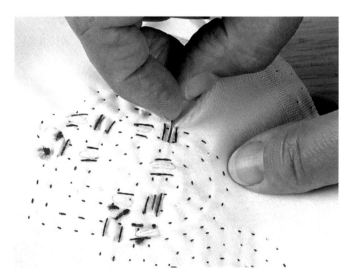

d

Applying Bias Binding

Bias binding is a handy way to finish off curved edges neatly, and if you choose a contrasting colour to your main project the binding can create an attractive border. You can make your own bias binding or use commercial binding, which usually has the two raw edges folded to the back. Unfold one edge and lay the binding, right side down, on the front of your work so raw edges align. Pin in place and work a line of hand or machine stitching along the fold line (Fig 20a). Trim the raw edges slightly if necessary and fold the binding over the fabric edges then slipstitch the folded edge to the back of the work (b).

Fig 20 Adding bias binding

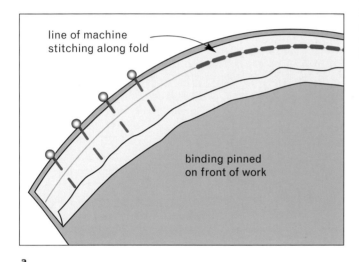

line of machine stitching along fold

binding pinned on front of work

a

slipstitching the folded edge of the binding on the back of the work

b

Making a Cushion Cover

There are many different methods of creating cushion covers but this is the most straightforward way of making a square cover, and therefore the quickest! Trim your quilted design to an accurate square – the size you want the finished cushion cover plus at least 1.2cm (½in) all round. Cut two rectangles of backing fabric, each the width of the front square by two-thirds of that measurement – so, if your square measures 45cm (18in), your rectangles will be 45 x 30cm (18 x 12in), as shown in Fig 21a. Turn under and stitch a small double hem on one long edge of each backing rectangle (b). Lay the front square right side up on a flat surface and cover it with the two backing rectangles, right sides down, overlapping them so raw edges align. Pin and then stitch a 1.2cm (½in) hem all the way around (c). Clip the corners, trim the seams and turn the cover right way out. To finish, press the very edges of the cover only, just to set the seams. The cushion pad can be slipped into the cover through the overlap at the back.

Fig 21 Making a cushion cover

a

b

c

PATTERN LIBRARY

If you've been inspired by the projects in this book, why not try creating your own Celtic designs? The motifs on the following pages can be used on their own for small projects, or combined for larger designs.

KNOTWORK

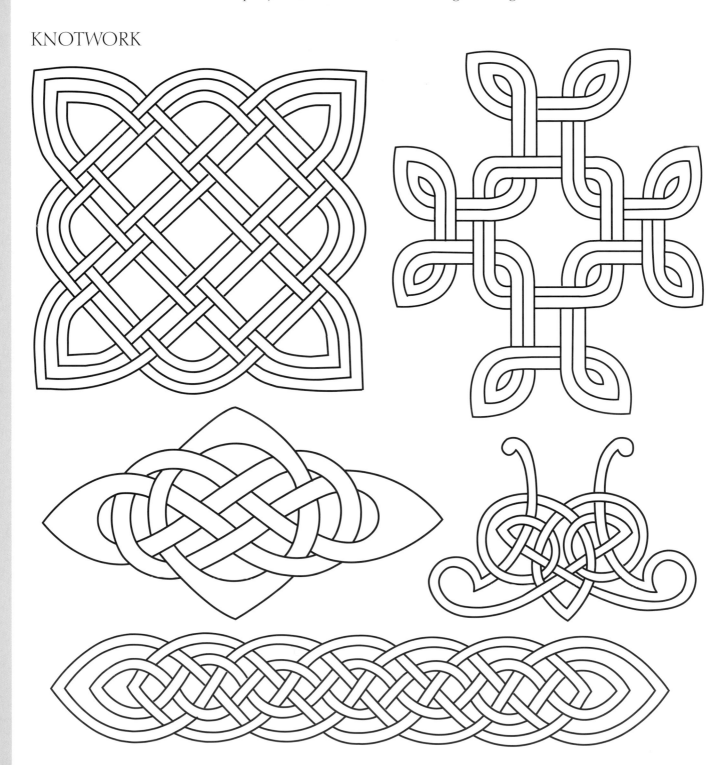

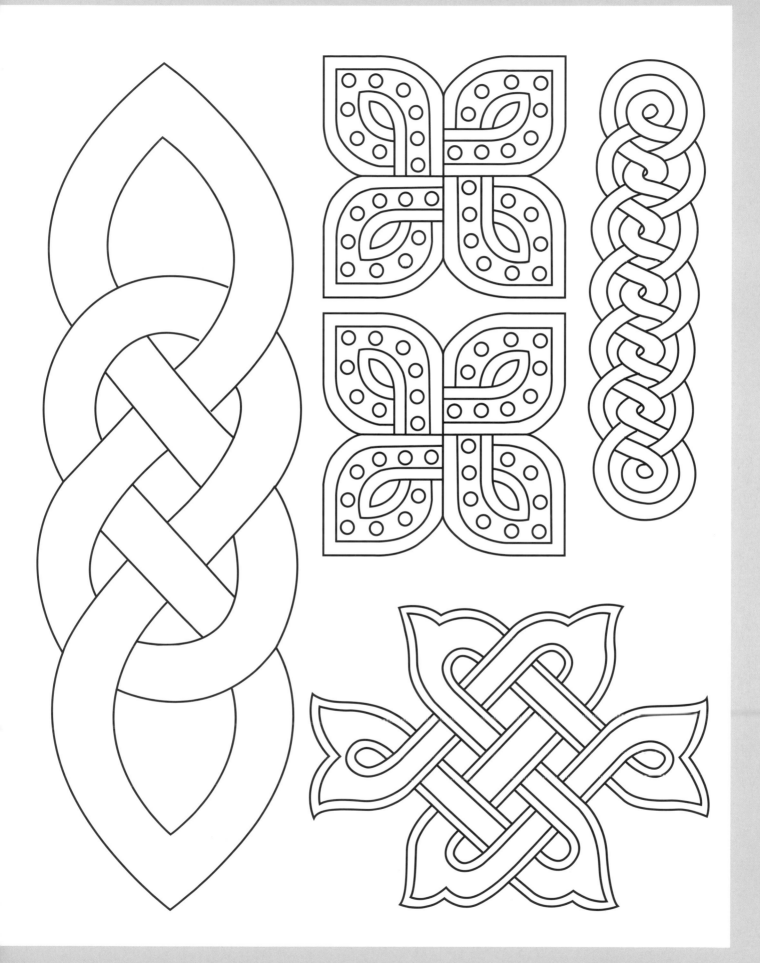

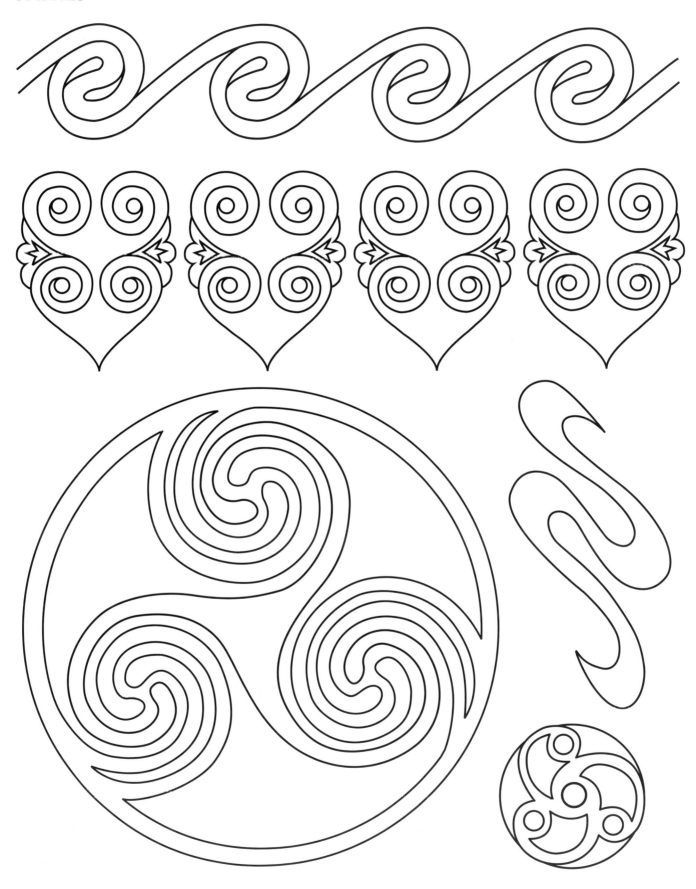

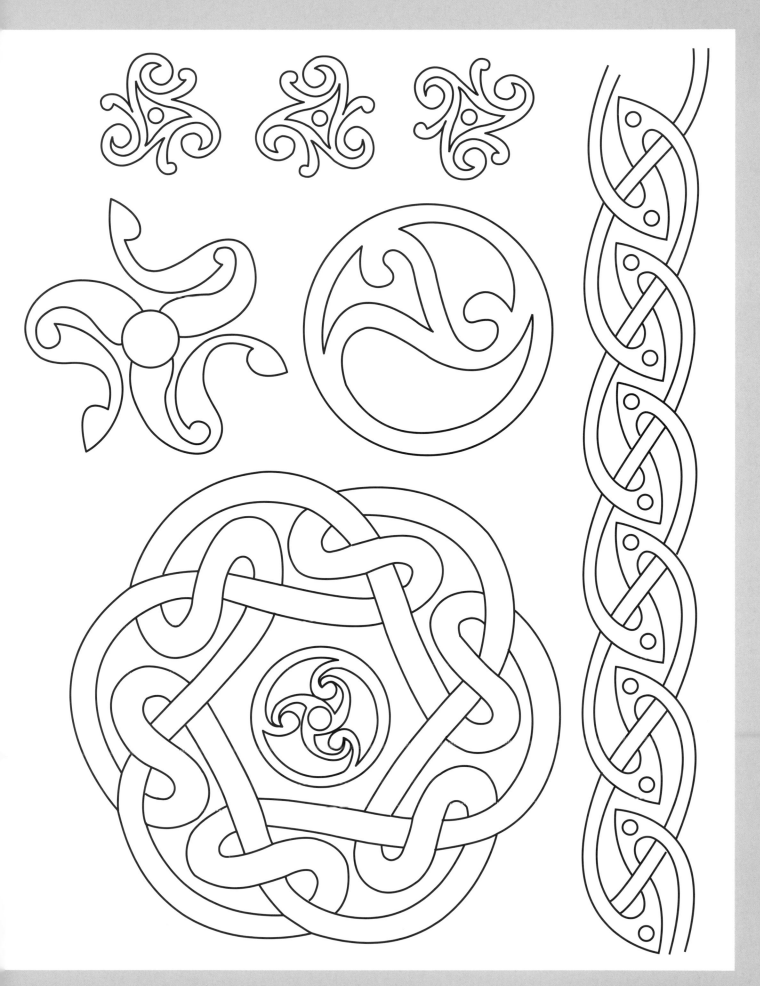

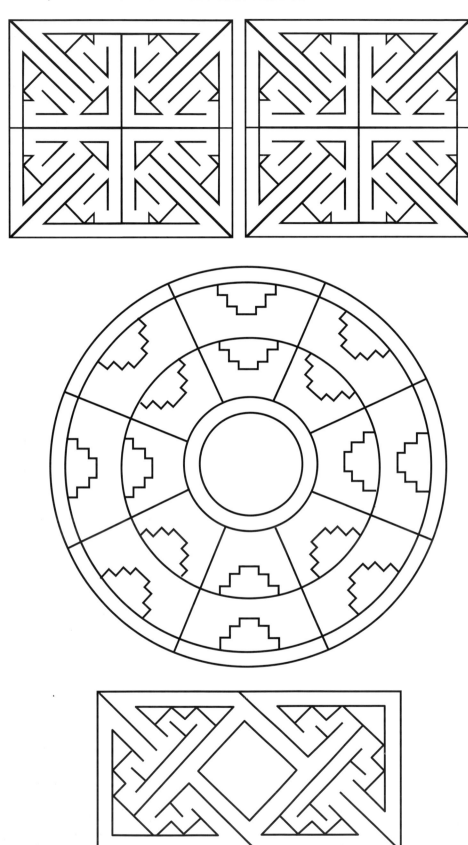

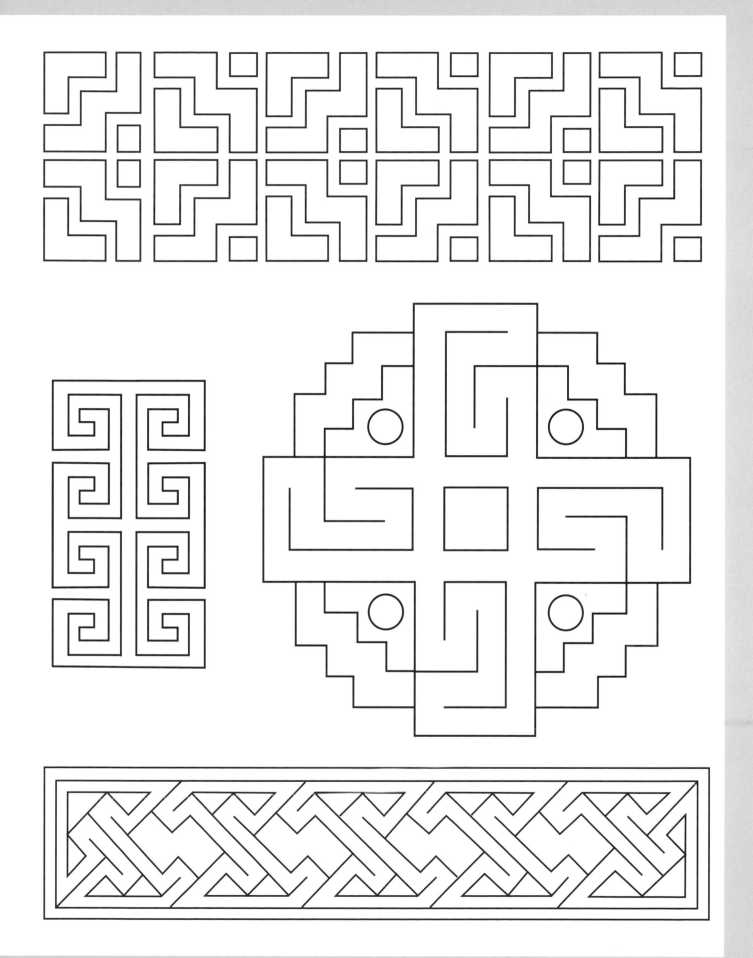

FURTHER READING

BACKHOUSE, Janet
The Lindisfarne Gospels
(Phaidon, 1994)

BAIN, George
Celtic Art: the Methods of Construction
(Constable, 1992)

BAIN, Iain
Celtic Knotwork
(Constable, 1992)

BAIN, Iain
Celtic Key Patterns
(Constable, 1993)

DAVIS, Courtney
101 Celtic Knotwork Designs
(David & Charles, 2004)

DOWN, Chris
The Crafter's Design Library: Celtic
(David & Charles, 2003)

LAWTHER, Gail
Celtic Cross Stitch
(David & Charles, 1996)

LAWTHER, Gail
Celtic Quilting
(David & Charles, 1998)

MEEHAN, Aidan
Celtic Design: Knotwork
(Thames & Hudson, 1992)

MEEHAN, Aidan
Celtic Design: Animal Patterns
(Thames & Hudson, 1992)

MEEHAN, Aidan
Celtic Design: Illuminated Letters
(Thames & Hudson, 1992)

MEEHAN, Aidan
Celtic Design: A Beginner's Manual
(Thames & Hudson, 1992)

MEGAW, Ruth and Vincent
Celtic Art
(Thames & Hudson, 1996)

NORDENFALK, Carl
Celtic and Anglo-Saxon Painting
(Chatto & Windus, 1977)

PEARCE, Mallory
Decorative Celtic Alphabets
(Dover, 1992)

PETRIE, Flinders
Decorative Patterns of the Ancient World
(Studio Editions, 1990)

ROWAN, Eric (editor)
Art in Wales 2000BC–AD1850, an Illustrated History
(Welsh Arts Council/University of Wales Press, 1978)

SPINHOVEN, Co
Celtic Stencil Designs
(Dover, 1990)

STEAD, Ian and HUGHES, Karen
British Museum Pattern Books: Early Celtic Designs
(British Museum Press, 2000)

STURROCK, Sheila
Celtic Knotwork Designs
(Guild of Master Craftsman Publications Ltd, 1997)

TINKLER, Nikki
Quilting With A Difference
(Craftworld Series, Traplet Publications, 2002)

de WAAL, Ester (editor)
The Celtic Vision: Selections from the Carmina Gadelica
(Darton, Longman & Todd, 1988)

SUPPLIERS

If contacting suppliers by post, remember to include a stamped, self-addressed envelope.

The Bramble Patch
West Street, Weedon, Northants
NN7 4QU, UK
tel: 01327 342212
For general quilting supplies

Clover EURO GmbH
10 Sudstrand D-21217
Seevetal, Germany
tel: 0049 (040) 768 99 982
web: www.clover-euro.de
Distributors of fusible bias binding

Coats Crafts UK
PO Box 22, Lingfield Estate,
McMullen Road, Darlington,
County Durham DL1 1YQ, UK
tel: 01325 365457 (for stockists)
*For Anchor stranded cotton (floss)
and other embroidery threads*

The Cotton Patch
1285 Stratford Road, Hall Green,
Birmingham B28 9AJ, UK
tel: 0121 702 2840
web: www.cottonpatch.net
For general quilting supplies

DMC Creative World
Pullman Road, Wigston,
Leicestershire LE18 2DY, UK
tel: 0116 281 1040
web: www.dmc/cw.com
*For stranded cotton (floss), coton perlé
and other embroidery threads*

Ells & Farrier
20 Beak Street, London
NW2 7JP, UK
tel: 020 7629 9964
web: www.creativebeadcraft.co.uk
For beads and sequins of all kinds

Gay Bowles Sales Inc
PO Box 1060, Janesville,
WI 53547, USA
tel: 608 754 9466
fax: 608 754 0665
email: millhill@inwave.com
web: www.millhill.com
For Mill Hill beads

Glitterati
Suite 9, Unit 1, Staples Corner
Business Park, 1000 North Circular
Road, London NW2 7JP, UK
tel: 0208 208 2232
fax: 0208 208 1233
web: glitterati2001@aol.com
*For glittery fabrics, metallic braids, beads,
exotic threads and sequins*

**Kreinik Manufacturing
Company Inc**
3106 Timanus Lane,
Suite 101, Baltimore,
MD 21244, USA
tel: 1800 537 2166
email: kreinik@kreinik.com
web: www.kreinik.com
For a wide range of metallic threads

Madeira (USA) Ltd
PO Box 6068, 30 Bayside Court,
Laconia, NH 03246, USA
tel: 603 528 4264
For Madeira threads

The Quilt Room
20 West Street, Dorking,
Surrey RH4 1BL, UK
tel: 01306 877307
web: www.quiltroom.co.uk
For general quilting supplies

Ragbags
Coney Garth, 3 Kirkby Road,
Ripon, North Yorks
HG6 2EY, UK
tel: 01845 526047
web: www.ragbags.net
For recycled fabrics

The Silk Route
Cross Cottage, Cross Lane, Frimley
Green, Surrey GU16 6LN, UK
tel: 01252 835781
web: www.thesilkroute.co.uk
For silk fabrics, threads and ribbons

Stef Francis
Waverley, High Rocombe,
Stokeinteignhead, Newton Abbot,
Devon TQ12 4QL, UK
tel: 01803 323004
web: www.stef-francis.co.uk
For space-dyed threads and fabrics

ABOUT THE AUTHOR

Gail Lawther is a freelance stitcher and author who has written around 20 books on many different types of needlecraft. Gail teaches and demonstrates quilting techniques at workshops and quilt fairs, and speaks regularly on her work to quilt groups in the UK. Gail has exhibited many of her pieces both at home and abroad, and has won numerous awards at national quilt festivals. She is also author of *Celtic Cross Stitch* and *Celtic Quilting*, both published by David & Charles.

Gail can be contacted at 44 Rectory Walk, Sompting, Lancing, West Sussex, BN15 0DU, UK. email: thelawthers@ntlworld.com web: www.gail-quilts-plus.co.uk

INDEX